SHREWSBURY AT WORK

Best wishes Nigel Hinton

NIGEL J. HINTON

AMBERLEY

First published 2018

Amberley Publishing
The Hill, Stroud
Gloucestershire, GL5 4EP

www.amberley-books.com

Copyright © Nigel J. Hinton, 2018

The right of Nigel J. Hinton to be identified as the
Author of this work has been asserted in accordance
with the Copyrights, Designs and Patents Act 1988.

ISBN 978 1 4456 7179 6 (print)
ISBN 978 1 4456 7180 2 (ebook)

British Library Cataloguing in Publication Data.
A catalogue record for this book is available
from the British Library.

Origination by Amberley Publishing.
Printed in the UK.

CONTENTS

ACKNOWLEDGEMENTS

I thank Bridget Hinton for her assistance with the research and support. I thank Shropshire Museum Service and Shropshire Archives for permission to photograph items in their collections, and the *Shropshire Star* for permission to use their archive of photographs. I thank the many individuals and companies included in this work who have given freely of their time and permission to use their photographs.

Research has been undertaken and oral contributions made by employees and former employees of the companies described in the book and these include the following:

1. The members of the Court of the Shrewsbury Drapers Company.
2. Bage & Hazledine – Dr Andrew Pattison.
3. Thomas Corbett – Mrs Elizabeth Morris.
Morris Lubricants – John Alton, Gina Hinde.
4. Sentinel – Bob Budden, and John 'Jumpy' Jones.
Wales and Edwards – Susan Overy and the late Dennis Maddocks.
5. Hartleys – the late Ron Gunn and the late Herbert Hulme.
Silhouette – Les Brown, David Cookson and the late Margaret Lobbenberg, and the Late Tom Blumenau.
6. Salop Leisure – Ed Glover and Tony Bywater and the directors.
Salop Design & Engineering – Chris Greenough and his fellow directors.
7. Morris & Company – Katie Morris.
Swan Hill House – the directors Mrs Carol Daker, Mr Charles Daker and Melanie York.
The Uplands – Mandy and Mark Thorn.
8. Wace Morgan – Diana Packwood, Trevor Wheatley and Carolyn Freeman.
Whittingham Riddell – the directors, Richard Whittingham and Jane Shaw.
9. Markets & Café Society – Kate Gittins of Shrewsbury Market Hall and Sarah Hart of Brightstone.

INTRODUCTION

Set on two hills and surrounded by a meandering loop of the River Severn, the town of Shrewsbury lies at the heart of the rural county of Shropshire. The town has developed since the seventh century in England's largest landlocked county and is on the longest English river, the Severn. It is Houseman's 'land of lost content'.

In Saxon times Scrobbesbyrig (a fortification on a scrubby hilltop of alders) became established and was thriving in 901, the date of the earliest historical evidence. The Normans established the town plan and by the twelfth century Shrewsbury had become the centre of the Welsh wool trade. Later, in the fifteenth century, a cloth trade developed and the pinnacle of the Welsh cloth trade was achieved in the sixteenth and early seventeenth centuries when the profits made enabled the successful middlemen, the drapers, to become some of the wealthiest of the very wealthy. They built large mansions to live in and generate income. Many timber-framed houses from the fifteenth, sixteenth and seventeenth centuries have survived and continue the practice using the ground floor for business with accommodation above.

Shrewsbury played its part in the Industrial Revolution in the eighteenth century: the Shrewsbury coalfield had some pits and mines that produced coal for local consumption and fuelled an ironworks created in Coleham by William Hazledine. He cast the components for bridges designed by Thomas Telford and for the earliest surviving iron-framed building, claimed to be the first skyscraper, built as a fireproof flax mill to the design of Charles Bage.

The nineteenth century saw an agricultural revolution in Shropshire and this was stimulated by the coming of the railways in the late 1840s. The availability of fast rail links to other towns and cities opened up markets for Shropshire's fresh produce. Agricultural engineers such as Thomas Corbett could also get their products to a far wider market and his investment in an ironworks in Castle Foregate was successful as he produced award-winning agricultural machinery for domestic and export markets.

The early twentieth century saw Shrewsbury become an engineering and manufacturing centre producing steam engines and later diesel engines made for trains, commercial vehicles and military applications. By the mid-twentieth century electrical and electronic engineers also developed here and various companies manufactured electrical assemblies and equipment, wiring kits, televisions, radios, record players and radiograms along with defence equipment.

Female emancipation reached the boardrooms of some family companies and female employment received a boost when a German corset manufacturing company moved from London to avoid the Blitz. Here some lucrative uniform contracts helped establish the company.

In the public sector, health and education continue to be the largest employers in Shrewsbury. The headcount of direct employees within Shropshire Council has reduced and some former employees have set up their own businesses to provide outsourced services. There has been a rise in professional services of lawyers and accountants as increasingly complex tax legislation of individuals and businesses has boosted demand for compliance and planning services. There have been a number of consolidations of individuals and small practices, and this enables specialist expertise to develop.

Leisure and care have become important sectors and as the internet has increased opportunities for home-based self-employment, Airbnb, Uber, Deliveroo and other internet businesses are operating in the town. The high street is under pressure from internet retailers to compete on price, but Shrewsbury still has many successful independent shops offering personal service. The Business Improvement District (BID) represents 540 members, of which 110 are independent retailers, and there are eighty-three independent bars, restaurants, coffee shops and hairdressers. Some businesses with smaller premises operate within the loop including Shrewsbury Market Hall, which has seen an increase in the number of quality dining places and was voted England's most popular market in January 2018.

Shrewsbury was said to be the graveyard of ambition, but that is another way of saying it has an excellent work-life balance. Charles Darwin, born here in 1809, would have approved of many local entrepreneurs who have grasped change, adapted their businesses and survived.

BUILT ON WOOL

Wool and the woollen cloth produced from local sheep have been economically important to Shropshire and the Marches region for centuries. This is not surprising as 'much of upland Wales and the Marches is good for nothing but cattle grazing and especially the grazing of sheep'. This chapter looks at the trade in wool and Welsh woollen cloth that grew up in the town.

Shrewsbury was ideally placed to become the main market in the high-quality Welsh wool trade located as it is on the River Severn. The merchants who traded in wool, drapers, were citizens of substance and a small number of families were in control. The greatest of these were the de Ludlowe family, who were moneylenders to the Crown and built Stokesay Castle.

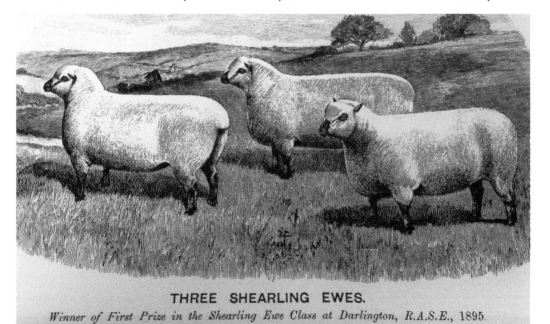

THREE SHEARLING EWES.

Winner of First Prize in the Shearling Ewe Class at Darlington, R.A.S.E., 1895.
Bred by and the property of Mrs. Maria Barrs, Odstone Hall, Atherstone, Warwickshire.

Shropshire sheep from the Flock Book of 1896. (Nigel J. Hinton)

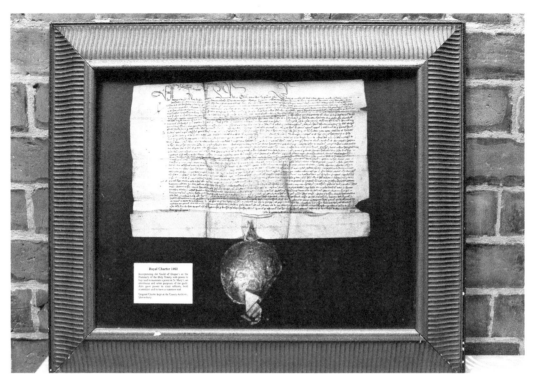

Drapers Charter from Edward IV 1462, from the copy in Drapers Hall. (Nigel J. Hinton)

In 1462, the wool merchants became an independent guild with strong links to St Mary's Church, 'A Fraternity or Gild of the Holy Trinity of the Men of the Mystery of Drapers in the town of Salop'. The drapers built a guild hall opposite St Mary's Church. From the hall they conducted the business of the guild, met and held feasts and on Saints days and important civic occasions the guild would process to St Mary's or St Chad's Church, having met and breakfasted in the hall.

Later, when Welsh woven cloth became available in the Marches border towns of Oswestry, Welshpool and Newtown, it was purchased by drapers and brought to Shrewsbury for processing and finishing. The finishers of the cloth were known as shearmen; they trimmed and tidied the cloth with long, sharp shears. They also became an independent guild. Their hall was in Milk Street and their chapel in St Julian's Church. Shearman's Hall was rebuilt in the nineteenth century as a chapel and is currently trading as Peaberry artisan food and drink.

In Frankwell raw wool was recovered from sheepskins by the fellmongers. They bought sheepskins, washed and treated them, then removed the wool by hand. The range of buildings in Frankwell was used for wool processing until 1974, then the trade ceased. The building was refurbished to become a community centre and the front is now home to the Pulse Hair Studio and the Little Boro fish and chip shop.

Wool and cloth was traded in the Square until 1596 when a new Market Hall was built by the town burgesses for the drapers to trade the cloth in the upper floor. The ground floor was used for other fresh produce and a corn market. The wool and cloth was then shipped out by packhorse and boat, around the country, Europe and North America. Today, following a major refurbishment of the old Market Hall on the upper floor there is an Independent cinema with a café-bar.

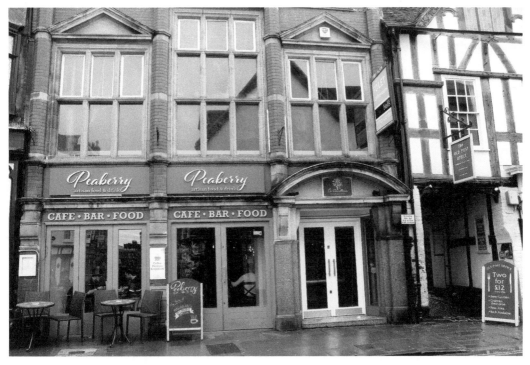

Above: Peaberry on the site of Shearman's Hall in Milk Street. (Nigel J. Hinton)

Below: The Fellmongers, Frankwell. (Nigel J. Hinton)

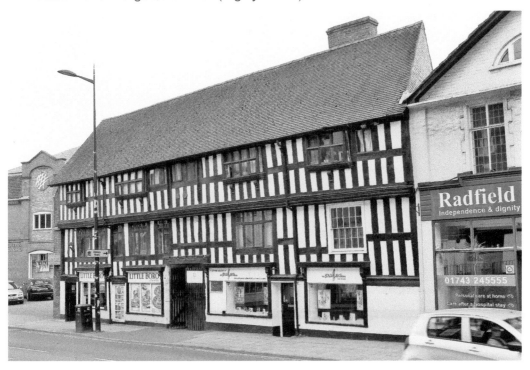

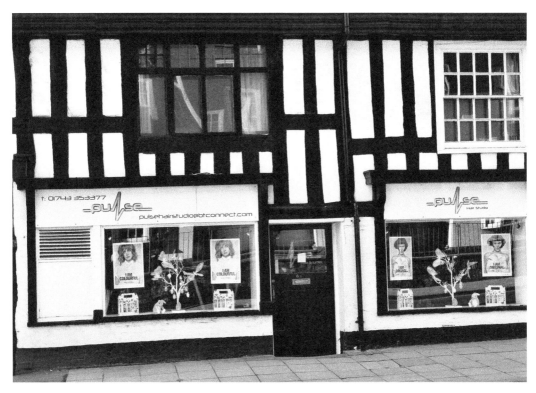

Above: Pulse hair studio in The Fellmongers. (Nigel J. Hinton)

Below: The Old Market Hall in the Square in 1843. (Nigel J. Hinton)

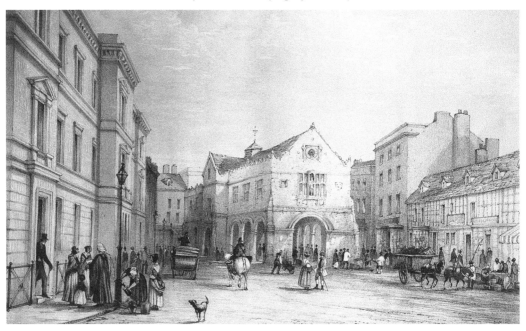

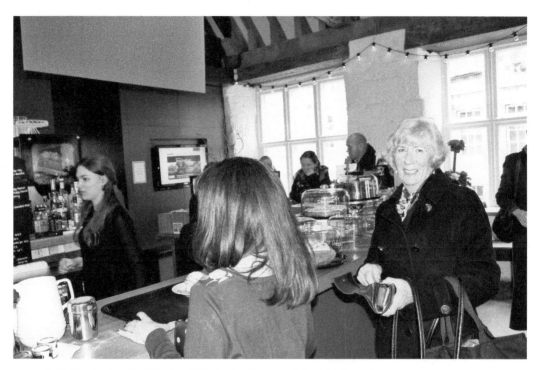

Café Bar in the Old Market Hall in the Square. (Nigel J. Hinton)

In the late sixteenth and early seventeenth centuries the drapers, as the middlemen, created a monopoly and became wealthy, and to display their fortune they built substantial town houses. William Jones lived on the High Street, in what is now used by Costa Coffee. His second son, Thomas, became the first mayor of Shrewsbury in 1638. Other dynasties included the Rowley's. Their mansion, presently unoccupied, has two parts. The first is the timber-framed warehouse, and the second is said to be the first brick house in Shrewsbury, built in 1618. Owen's mansion has the Edinburgh Woollen Mill and Ask Italian restaurant and Proude's mansion is used by Rizzo Hairdressing.

The members of the guilds would have formal meetings and feasts in their halls or in public hostelries and Drapers Hall is an excellent example of a sixteenth-century guild hall. It is one of a handful of surviving halls in use by the original guild in England, and is special as it also has its own original seventeenth-century furniture inside. It is managed by Shrewsbury Drapers Hall Preservation Trust, a charity, and is used by the company for feasts. It is open to the public as a boutique hotel and restaurant.

In the eighteenth century individual drapers gave generously to charity and James Millington left money for almshouses and a school to be built in Frankwell. Today the almshouses have been brought up to standard and continue to be used for their original purpose, but the school is closed. On Town Walls John Bowdler left part of his fortune to fund a school, which is now used as dental practice. In 1762 the Shrewsbury Drapers Co. granted a lease of ninety-nine years to Thomas Coram to start a foundling hospital on land that was subsequently acquired by Shrewsbury School in 1882. Following further investment the school is now a co-educational independent school for pupils aged thirteen to eighteen. The school is an important employer in the town.

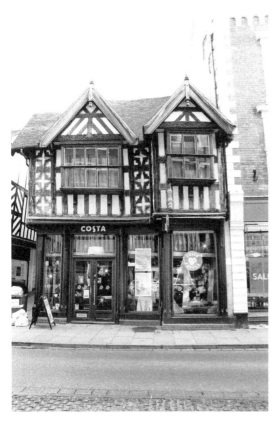

Left: William Jones' Mansion, High Street. (Nigel J. Hinton)

Below: Rowley's Warehouse, Barker Street. (Nigel J. Hinton)

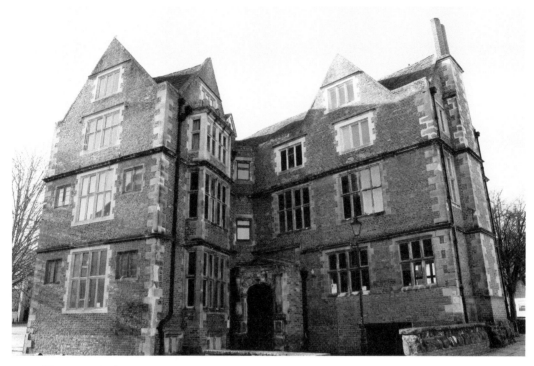

Above: Rowley's Mansion, Hills Lane. (Nigel J. Hinton)

Below: Owen's Mansion, the Square. (Nigel J. Hinton)

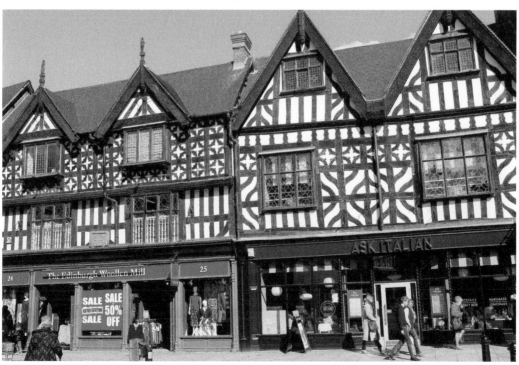

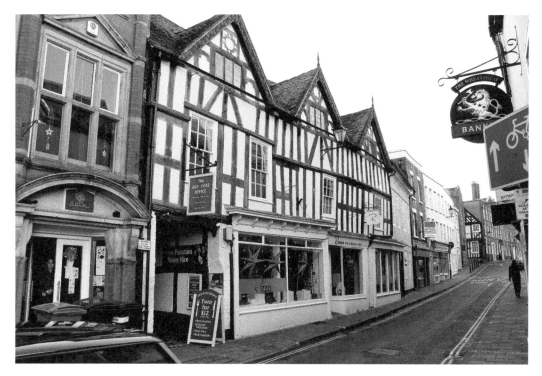

Above: Proude's Mansion, Milk Street. (Nigel J. Hinton)

Left: Drapers Hall, St Mary's Place. (Nigel J. Hinton)

Above: John Bowdler's School, Town Walls. (Nigel J. Hinton)

Below: Shrewsbury School overlooking the River Severn. (Nigel J. Hinton)

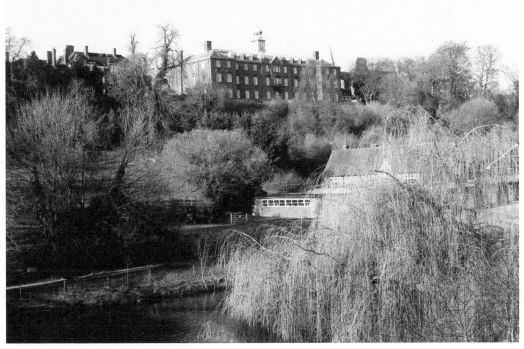

By the early nineteenth century the Welsh cloth trade had ceased due to the industrialisation of weaving. The guild membership dwindled and the remaining handful of drapers managed to rebuild their almshouses in 1825. But they were hit again in 1835 when the Corporation Acts stripped all the guilds throughout England of their remaining trading privileges; however the charitable aspects of the guilds were allowed to continue. Today The Shrewsbury Drapers Company Holy Cross Ltd has almshouses on four sites in Shrewsbury: Fairford Place; the Hospital of St Giles; the Hospital of The Holy Cross; and the latest addition, Drapers Place, opened on 17 June 2017 by HRH The Duke of Gloucester. The company also promotes an annual Textile Design Competition for adults, students and school-age children. Entries are displayed in the Drapers Chapel in St Mary's Church.

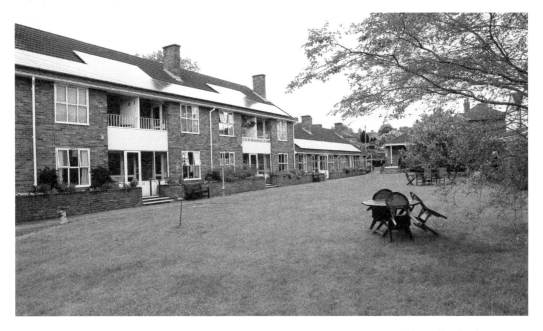

Above: Fairford Place, Coleham. (Nigel J. Hinton)

Left: The Hospital of St Giles, Wenlock Road. (Nigel J. Hinton)

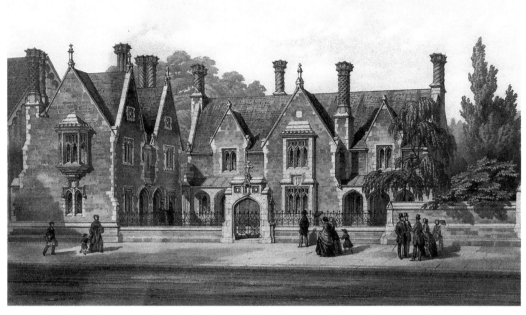

Above: The Hospital of The Holy Cross, Abbey Foregate. (Brian Newman collection)

Below: Drapers Place, opened by HRH The Duke of Gloucester with Master Ashley Fraser and the author. (Richard Bishop)

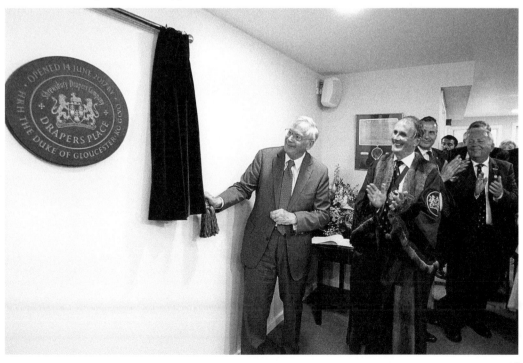

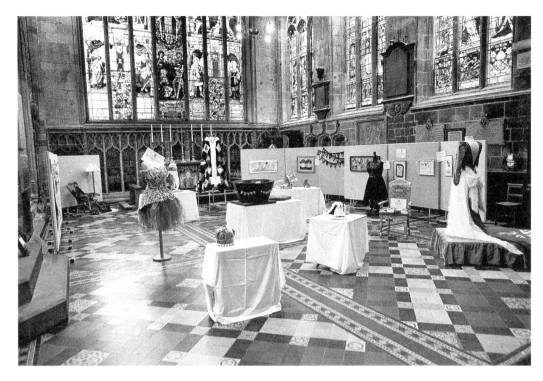

Above: Textile Design Competition, Drapers Chapel, St Mary's. (Richard Bishop)

Left: Louise Cameron's gold, award-winning entry in 2012. (Richard Bishop)

THE FIRST SKYSCRAPER?

This chapter examines the engineers and designers who have left their mark in the form of the town's built environment. Although some timber-framed buildings were lost in the post-war development and modernisation, there is much that remains and many old buildings are still in daily use or there are plans for their future use. In Shrewsbury many timber-framed homes were modernised in the Georgian or Victorian periods with new brick fronts added to keep them in fashion and to reduce drafts. Homes were used for commercial purposes on the ground floor, with the owners' apartments on the first floor, and in some the upper floors were let to tenants. With the coming of the Industrial Revolution production moved from workshops into purpose-built manufactories, which employed large numbers of men, women and children. This chapter looks at some surviving domestic, secular and industrial buildings and works and their designers and builders.

CHARLES BAGE

Charles Bage had several strings to his bow and after his family moved from Derby, where he was born in 1752, he set up business as a wine merchant in Shrewsbury. He was also a surveyor and a founder and director of the 'House of Industry' in 1794, originally built as Coram's Foundling Hospital.

The Benyon Brothers entered into partnership with John Marshall of Leeds to build a fireproof flax mill in Ditherington and they appointed Charles Bage as its designer. He was the first to use cast-iron beams, as well as the columns, roof supports, windows and doors. This development, it is claimed, makes the construction of the flax mill the template for the skyscrapers that followed and is the oldest surviving example of this use of iron. It was completed in 1797. As profits increased so did employment, and by 1813 over 400 people worked there. This had risen to over 800 by 1845. But then as profits reduced by 1851 the number employed had reduced to 377. Of these, just over half were children under twenty years of age, and of these one third were under the age of sixteen. Children were apprenticed from age eleven or twelve or until age twenty-one; girls finished their apprenticeship if they married earlier. The flax mill did not remain competitive and was sold to William Jones Maltsters in 1897. They went bankrupt in 1934. During the Second World War it was used as a barracks by the Kings Shropshire Light Infantry and returned as a maltings for Ansells

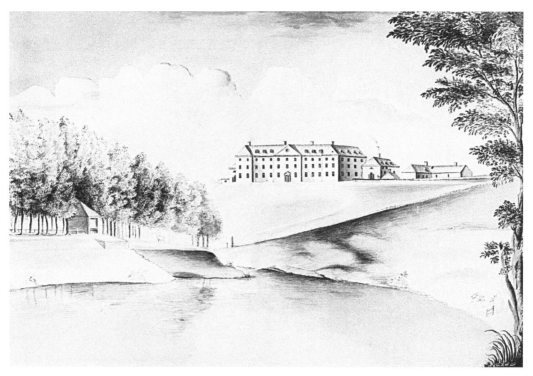

Above: Coram's Foundling Hospital, later the House of Industry, 1794. (Shropshire Archives)

Below: The Flaxmill Maltings, Ditherington. (Nigel J. Hinton)

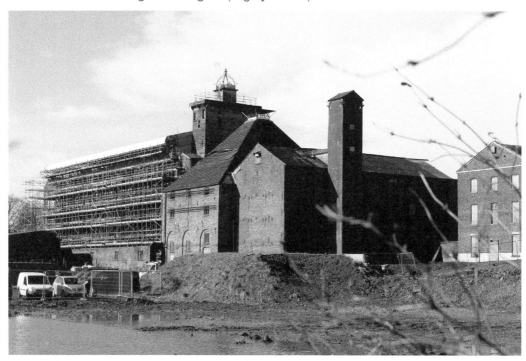

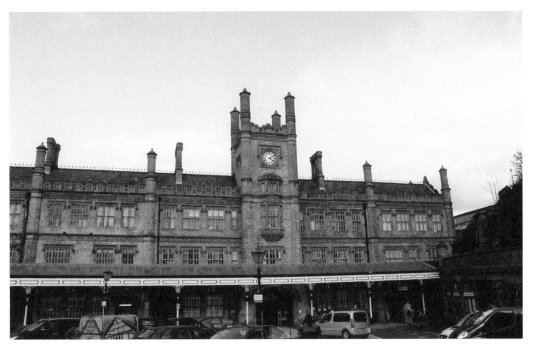

Shrewsbury Station, Castle Gates. (Nigel J. Hinton)

Brewery from 1948 until it closed in 1987. Historic England acquired the site in 2005 and now a master plan has been agreed to redevelop it as the Flaxmill Maltings.

Bage designed another mill in Castlefields, Shrewsbury, in 1804 for the Beynon Brothers. He had time to be active in local politics and was elected Mayor of Shrewsbury in 1807. He was the designer of the original Lancasterian School, which opened in 1812 with 233 pupils. Shrewsbury station was built on the site and the school relocated in 1851. The arrival of the railways stimulated the need for workers and new homes were built at 'the back of the sheds'. The senior employees moved into the Belle Vue area of Shrewsbury.

THOMAS TELFORD

Thomas Telford was born on 9 August 1757 at Glendinning sheep farm in the parish of Westerkirk, Eskdale, Dumfriesshire. After leaving school he was apprenticed to a stonemason and having gained some experience in Edinburgh, he moved to London. Here he met the architect Robert Adam and became a good friend of William Pulteney, later MP of Shrewsbury. Telford moved to Shrewsbury to undertake the restoration of Shrewsbury Castle as Pulteney's occasional residence. Windows and doors were installed and rooms in the drum towers were made habitable and are used as the Mayor's Parlour. Laura's tower was built for Pulteney's daughter.

From July 1787, Telford was appointed as Shropshire County Surveyor of public works. He worked on the county infirmary, private houses, street improvements, drainage, and the restoration of St Mary's, Shrewsbury, and All Saints', Baschurch, and a new church, St Mary Magdalene, in Bridgnorth. In the next year at Pulteney's request Telford inspected St Chad's Church, Shrewsbury. He forecasted that it was about to collapse and his reputation was made when within a short time the tower collapsed into the crypt.

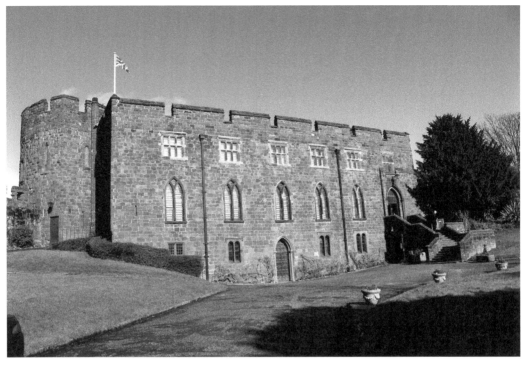

Above: Shrewsbury Castle, Castle Gates. (Nigel J. Hinton)

Below: Interior of the Mayor's Parlour, Shrewsbury Castle. (Nigel J. Hinton)

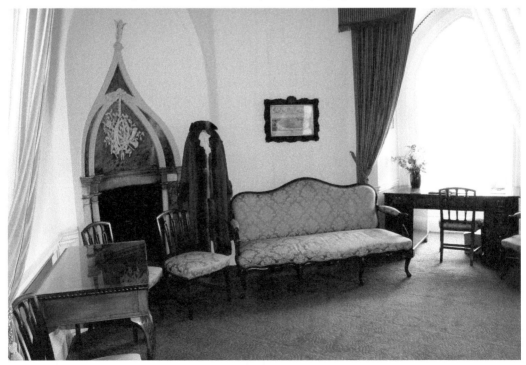

Right: Laura's Tower on top of the motte in Shrewsbury Castle. (Nigel J. Hinton)

Below: Collapsed crypt of Old St Chad's Church, Princess Street. (Nigel J. Hinton)

In 1793, he was appointed as General Agent, Surveyor, Engineer and Architect to the important 68-mile Ellesmere Canal, which includes the aqueduct built at Pontcysyllte, the supreme engineering achievement of the Canal Age. Telford supervised and engineered the building and repairing of many roads including the London to Holyhead road, the A5, which includes the Menai wrought-iron suspension bridge. In 1813, he designed Cantlop Bridge as part of a scheme to improve roads in Shropshire. He used a small team of trusted local businessmen and contractors who employed several hundred navvies and engineers to do the hard manual work.

He moved to the Salopian Coffee House in London in 1800, then to No. 24 Abingdon Street in 1821 until his death on 2 September 1834. Buried in Westminster Abbey, this 'Colossus of Roads' has a lasting memorial of roads, bridges and buildings but is also remembered by the name of the new town of Telford in Shropshire a few miles east of Shrewsbury.

WILLIAM HAZLEDINE

William Hazledine was born in Shrewsbury on 6 April 1763 and became apprenticed to his uncle for seven years in 1778. He worked as a millwright around Shropshire and began to specialise in ironwork. By 1792 he was involved in making the ironwork in the new St Chad's Church, and in the following year he built a foundry in Coleham, which five years later, in 1797, was used to produce the ironwork for Bage's flax mill in Ditherington. He prepared the detailed design work and cast all of the components. These included 204 columns, 136 beams, 136 large windows, and nineteen roof sections, iron doors, tie bars, staircases, and all the other smaller cast-iron parts that all had to fit together. He replaced the ironwork on the Old Market Hall.

Portrait of William Hazledine and a test link in Shrewsbury Museum. (Nigel J. Hinton/ Shrewsbury Museum)

St Chad's Church, St Chad's Terrace. (Nigel J. Hinton)

In 1812, he made the ironwork for Cantlop Bridge, the Menai Bridge and Pontcysyllte working as part of Telford's team. At its peak the Coleham foundry employed 300–400 people. Later in life he turned to politics and in 1832 he was elected a freeman of Shrewsbury. In 1836, he was elected as the Mayor of Shrewsbury and continued to invest in property in Shrewsbury. He was a founder of Shrewsbury Racecourse in Monkmoor. He died on 26 October 1840 and was buried in St Chad's Church. His memorial is near the pulpit.

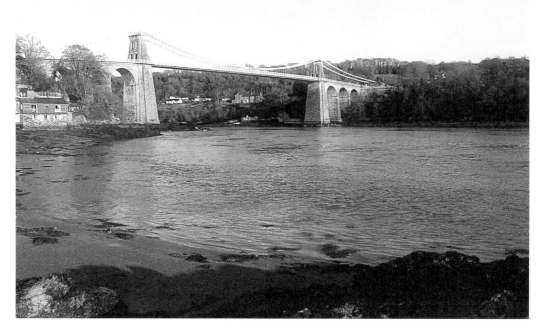

Above: Cantlop Bridge.
(Nigel J. Hinton)

Left: Ironwork on the Old Market Hall.
(Nigel J. Hinton)

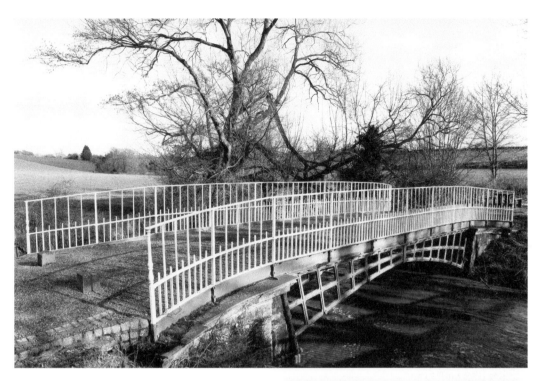

Above: Menai Bridge, Anglesey.
(Darryl Evans)

Right: Hazledine Memorial in St Chad's
Church. (Nigel J. Hinton)

ENGINEERING AND TRANSPORT

This chapter examines two of the engineering and manufacturing companies that started up in Shrewsbury in the first half of the twentieth century, driven both by the demands of war and the increasing popularity of motor vehicles.

SENTINEL STEAM WAGON COMPANY

The Sentinel Steam Wagon Company returned to Shropshire in 1915, having acquired Simpson and Bibby in Horsehay, Shropshire, in 1903, and moved the manufacturing of steam wagons to Glasgow. Stephen Evans Alley had taken over the business from his father, and was keen to profit from the demand for war materials. But after the war demand slumped the business went into liquidation, after which a new company was formed to take over the assets and liabilities. This was Sentinel Wagon Works (1920) Ltd.

Later, in the 1920s, production increased both in volume and in the range of products sold, which now included locomotives as well as steam wagons. The company employed skilled engineers who designed and made machine tools for their own use and for resale. The company had extensive holdings of land and built homes for the workers opposite the factory. These had the benefit of central heating with radiators using recycled steam fed from the company's boilers by pipes that went under the main A49 Whitchurch Road.

By the 1930s the unladen weight restrictions of road-going vehicles meant that diesel was favoured at the expense of the much heavier steam wagons that, in addition to the load, had to carry their own fuel of coal and water. The company stayed too long with steam, and liquidation followed. A new company took over the assets and liabilities and started trading as Sentinel Wagon Works (1936) Ltd. Again the prospect of war turned the company around, as it gained substantial military contracts for the supply of machine tools and vehicles for active service. The vehicles included Sentinel locomotives, Universal Carriers (Bren Gun Carriers), Loyd Carriers, Locust tanks (a lightweight tank used on D-Day), Stuart tanks, the Ram ARV Mk II (armoured recovery vehicle) and Sentinel steam wagons.

Within all industries and commerce there is always demand for skilled people and many former directors and employees of Sentinel moved to work with other engineering companies that were set up or were started by colleagues. These included Woodvines, Asquith, Norton Asquith, Norton Machines and Warner Swasey and Rolls-Royce, Perkins and Caterpillar

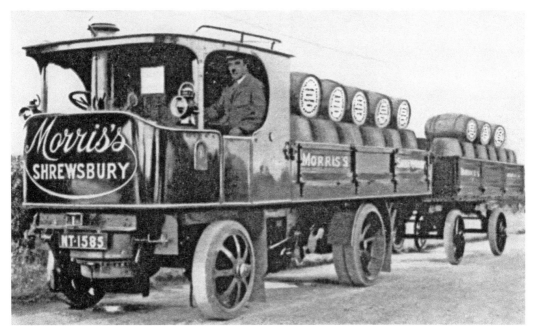

Above: A Sentinel. (Morris Lubricants)

Below: Sentinel workers' houses. (Nigel J. Hinton)

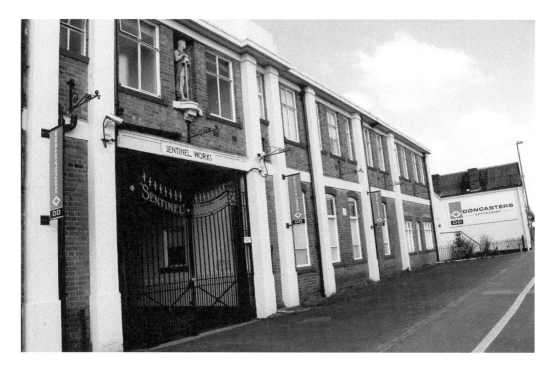

Doncaster's Sentinel Works. (Nigel J. Hinton)

remanufacturing. The Sentinel site is now occupied by Doncasters Aerospace Components, manufacturers of machined and fabricated casings and related products. Around 200 people are employed at the Sentinel works.

WALES & EDWARDS

Wales & Edwards were motor engineers based at Morris House, at the bottom of Wyle Cop, and fuel and motor cars were sold, serviced and repaired. The showroom had a feature concave window where the cars were displayed. These included Morris, Wolseley and Rover; Humber; MG; and Morris commercial vehicles. The departments offered specialists in 'Servicing of Vehicle Electrical work, Welding and Bodywork, Hoods and Batteries, Painting and Washing' and claimed they sold 'Satisfactory Motoring'.

Training and customer service were important to W&E and these things were achieved by a dedicated service team including Edward Raymond Morgan (Ray), who was their 'Man with the Van' or 'Service Inspector'. In 1937 Ray was awarded the William T. Thorne silver medallion for being the best candidate in the annual examinations of the West Midland Centre of the Institute of the Motor Trade (Incorporated).

In 1942, the garage was split in two with one division concentrating on essential car users – such as doctors, vets and farmers – who had to have a 'Certificate of Need to Buy Spares' in order to get their cars serviced. The other was the Military Vehicle Division and here damaged military vehicles came to be repaired and refurbished, including Morris 15 cwt Quads and mobile workshops. The vehicles were stripped down across the road at the Barge Garage, then taken to the unit shop on an electric truck driven by Mrs Betty Parsons.

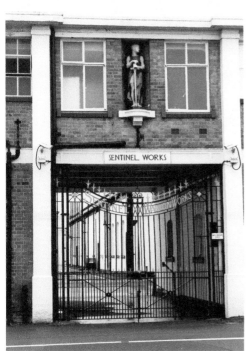

Above left: The Sentinel keeping watch over the main entrance. (Nigel J. Hinton)

Above right: Wales & Edwards sold Satisfactory Motoring in the 1930s. (Susan Overy collection)

Below: Repair shop No. 2 in Morris House, Wyle Cop. (Susan Overy collection)

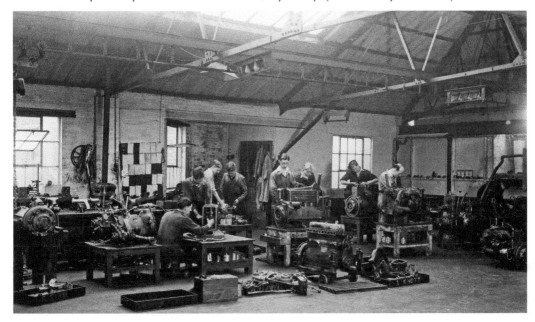

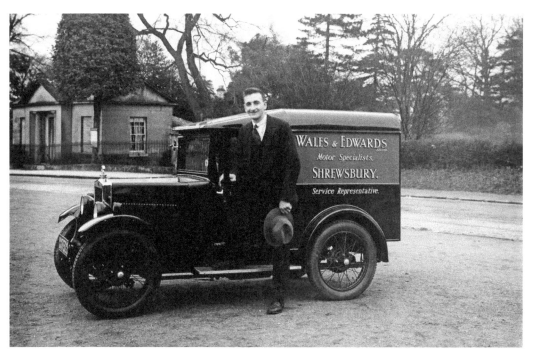

Above: Ray Morgan, service representative, in 1932. (Susan Overy collection)

Below: Repair workshop in Morris House. (Susan Overy collection)

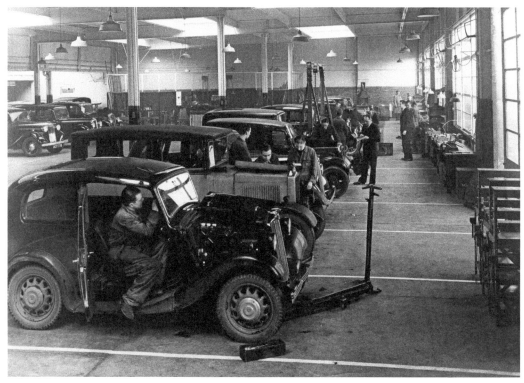

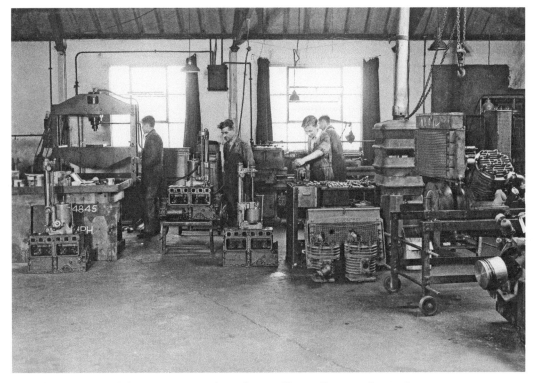

Above: Stripped-down engines and gearboxes. (Susan Overy collection)

Below: Damaged vehicles from Dunkirk awaiting repair. (Susan Overy collection)

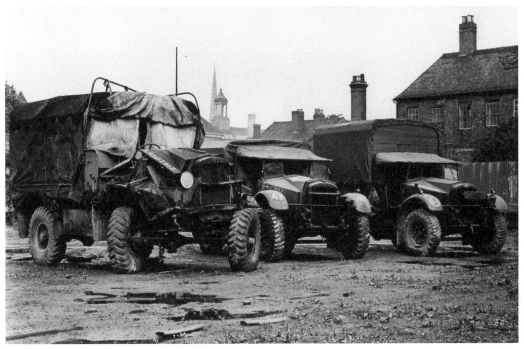

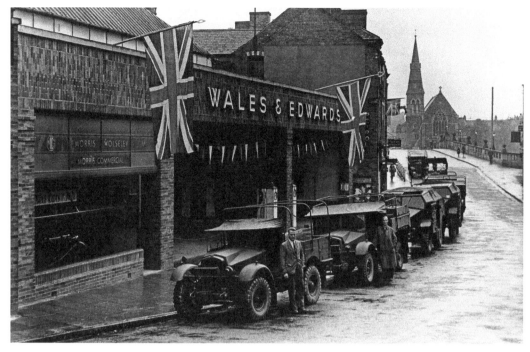

Above: Completed repairs to be returned to active service. (Susan Overy collection)

Below: An early electric vehicle used for moving components around. (Susan Overy collection)

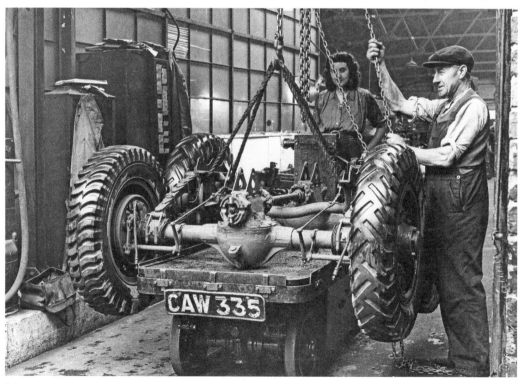

The stripped-down units, engines, gearboxes, back axles and all mechanical components were rebuilt to a very high standard in the engineering workshop, then taken back to the Barge to be reunited with the bodywork and delivered to the army. A REME officer from Bicester visited the company and stated that the men preferred the reconditioned units as they were more reliable than new units from the factory.

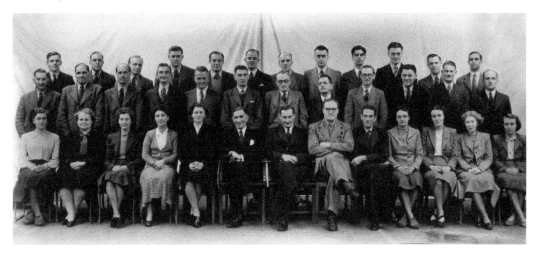

Above: Wales & Edwards staff photograph. (Susan Overy collection)

Below: Wales & Edwards milk floats in Shropshire Dairy. (Nigel J. Hinton)

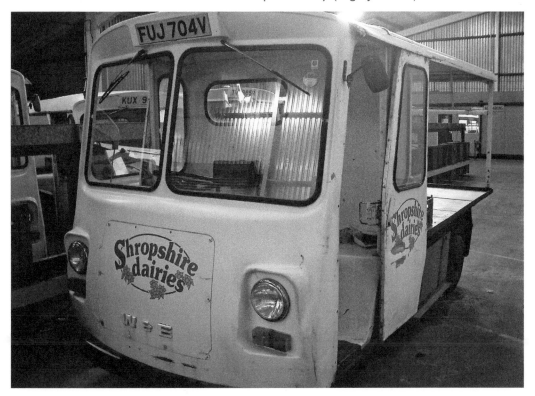

Cars were in short supply during and in the first few years following the end of the Second World War and horses continued to be used to carry and deliver goods and daily supplies of bread and milk to households around the country. Horses were expensive to feed and keep and they could not work all day without rest. Mervyn Morris designed a battery-operated electric vehicle in the Barge Garage and this evolved into a milk delivery vehicle. The first vehicle was delivered to Roddington Dairy in early 1951. Wiring harnesses were supplied by Hartleys in Monkmoor and W&E continued to make electric vehicles in Harlescott until the 1970s. A number of the vehicles are still in use in and around Shrewsbury today by various dairy companies.

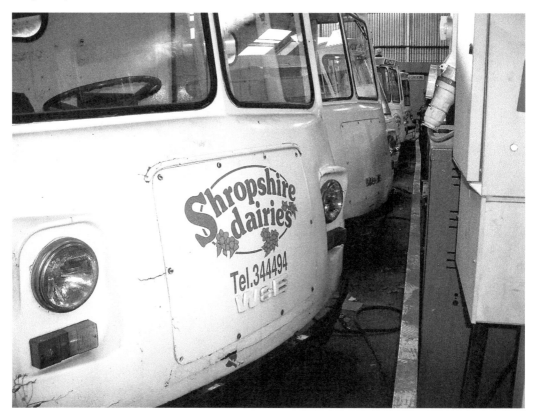

Wales & Edwards milk floats recharging in the dairy. (Nigel J. Hinton)

PERSEVERANCE IRONWORKS AND MORRIS LUBRICANTS

Shrewsbury avoided bomb damage during the Second World War and so many of its old buildings appear to remain intact. However, many have undergone significant change behind their façade. In this chapter we look at the inspiration behind the man who built, and the present occupier of, the Perseverance Ironworks in Castle Foregate.

THOMAS CORBETT

Thomas Corbett came from a family of blacksmiths and agricultural engineers in Wellington, Shropshire. He set up his business in Shrewsbury in 1865 and sold his products through Richard Chipchase, of Albert Street and Castle Foregate, and they worked together until 1877.

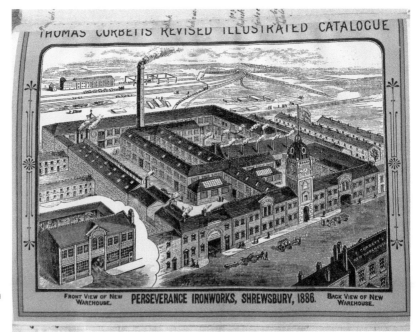

Catalogue picture of the Perseverance Ironworks, Castle Foregate. (Mrs Elizabeth Morris collection)

THOMAS CORBETT'S REVISED ILLUSTRATED CATALOGUE

FRONT VIEW OF NEW WAREHOUSE. PERSEVERANCE IRONWORKS, SHREWSBURY, 1886. BACK VIEW OF NEW WAREHOUSE.

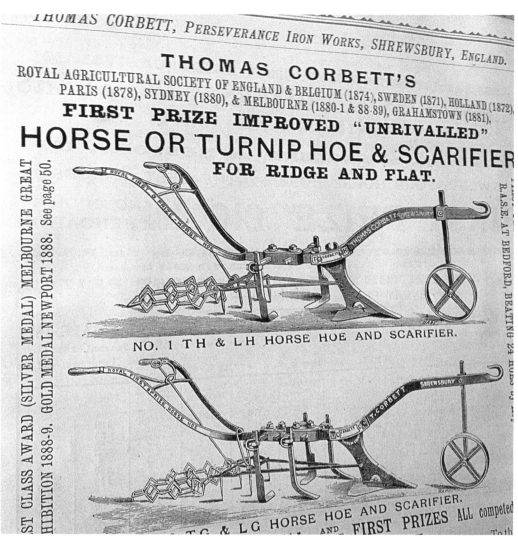

Advertising catalogue award-winning horse or turnip hoe and scarifier. (Mrs Elizabeth Morris collection)

Thomas worked with another seller, Arthur John Peele, until 1881. Corbett then became sole proprietor of the firm. He was a successful businessman and an award-winning agricultural engineer.

He was an exceptional innovator, as can be gathered from an advertisement of 1914 where he claims to have won 'more than 800 Royal Agricultural Society of England and other First Prizes, Gold & Silver Medals, Diplomas for Honour & Other Disinctions'. He grasped new ideas and new technology and was part of the drive for more mechanisation on farms. He travelled internationally and had great success in selling products in the Commonwealth countries. The Perseverance Ironworks employed several hundred men and made a variety of iron products in the foundry on the site.

As well as having a busy working life, Thomas Corbett made time to become the first secretary of the Shropshire Chamber of Agriculture, when it was launched shortly after cattle plague hit Shropshire in 1865. Thomas Corbett was again involved as the first secretary of

Right: Ploughing award won by Thomas Corbett with Mr John Corbett, a descendent. (Nigel J. Hinton)

Below: Winnower in Morris Lubricants, Castle Foregate. (Nigel J. Hinton)

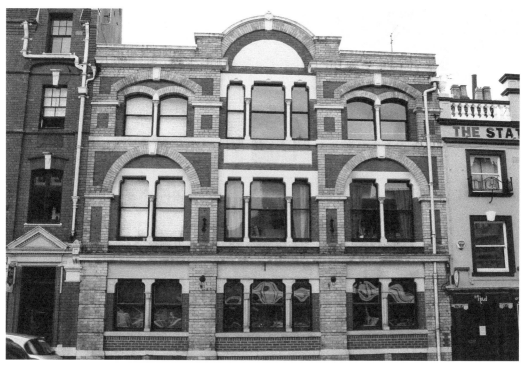

Above: Showroom of Thomas Corbett. (Mrs Elizabeth Morris collection)

Below: Corbett's employees, late nineteenth century. (Mrs Elizabeth Morris collection)

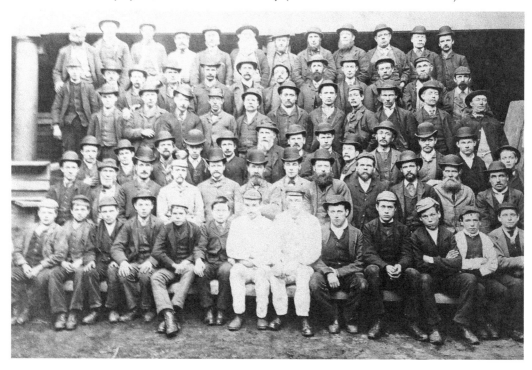

Thomas Corbett in later life. (Mrs Elizabeth Morris collection)

the Shropshire and West Midlands Agricultural Society when it was founded in 1874. Both of these organisations flourish today. In later life Corbett took on civic responsibilities and became a councillor and in 1906 he was made Mayor of Shrewsbury. He continued to be involved in business and civic duties, which enabled him to meet George V at the Royal Show in 1914, held on the Shrewsbury racecourse. There is a memorial to this successful Victorian entrepreneur in the United Reform Church near the English Bridge.

MORRIS LUBRICANTS

Morris Lubricants began life at No. 7 Frankwell in 1869 when James Kent Morris opened a grocery store and wax chandlery. He ran the business for twenty-two years until his death in 1891. His eldest son James, known as JK, took over from his father. He was just eighteen years old and so had the support of his father's trustees for the day-to-day running of the grocery business. JK spent ten years as a travelling salesman for the Anglo-American Oil Company before becoming involved with the family business. Naturally the company diversified beyond groceries to supply surplus oils purchased under tender from the Disposal Board set up following the First World War, thus Morris Lubricants was born.

JK was also politically active and in 1903 he became Shrewsbury's first Labour councillor. The grocery business expanded in December 1913 when Morris's Café opened at No. 25 Pride Hill. The café had a grocery business, a roof garden and the dance floor was a popular meeting

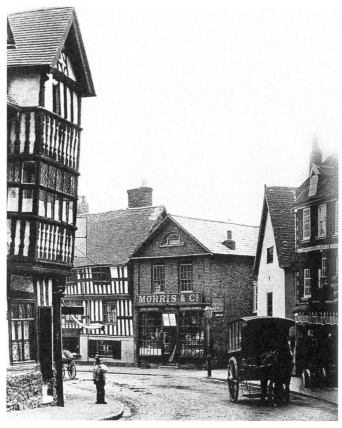

Left: Morris's grocery shop at No. 7 Frankwell. (Morris Lubricants)

Below: Site of former Morris's Café in Pride Hill. (Nigel J. Hinton)

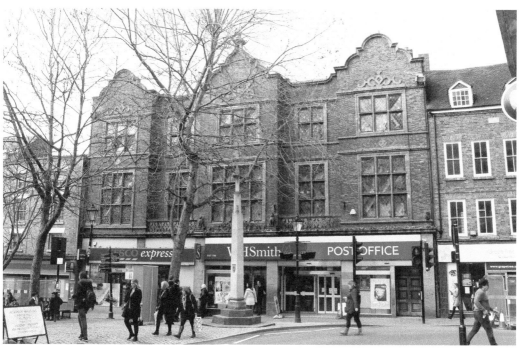

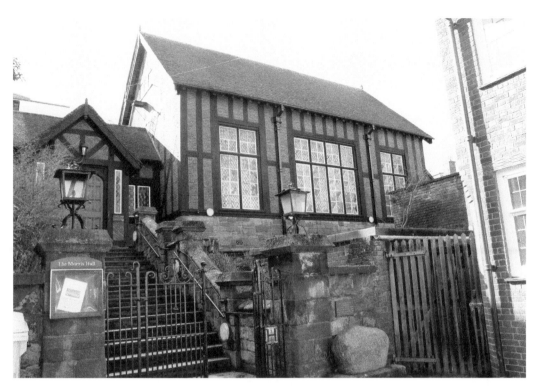

Morris Hall in Barker Street. (Nigel J. Hinton)

place for social events, parties and dinner dances. JK funded the new build of the Bellstone Hall on the garden site of the dilapidated Owen's Mansion, built originally in 1582. The new building was cleverly designed to have two distinct sections – one of a fourteenth- and the other a sixteenth-century style – and was heavily influenced by the arts and crafts movement. It was opened in 1933 and transferred to a trust in 1935. It was renamed the Morris Hall after JK's death.

The move to lubricants was well timed as there was an increase in demand for lubricant products for cars, lorries, commercial and leisure vehicles, steam and diesel engines. Meanwhile the Morris Company had become incorporated in 1922 and the lubricant division remained part of the Morris Group until 2003, when Paterson Enterprises Ltd was created. The link with the founder was maintained as Leonard Paterson was a nephew of JK, and descendants and family members such as Andrew Goddard are directors of Morris Lubricants.

The manufacturing facility relocated to the Perseverance Ironworks and is easily identifiable by its iconic clock tower. As technology has advanced the science of lubrication has had to develop to work with new materials and higher specification engines with longer service intervals. The state-of-the-art laboratories are equipped with the latest cutting-edge lubricant testing and analysis equipment.

UK and international logistics operations are managed centrally from Shrewsbury by the company's own fleet of vehicles. The international business exports to over eighty countries worldwide. The company has a division that enables it to prepare lubricants for specialist requirements in high-performance vehicles and heritage transport, including steam, diesel and petrol-powered engines and gearboxes. There are around 230 people employed in the company in Shrewsbury.

Above: Andrew Goddard, managing director. (Morris Lubricants)

Below: Perseverance Ironworks with iconic clock tower, Castle Foregate. (Morris Lubricants)

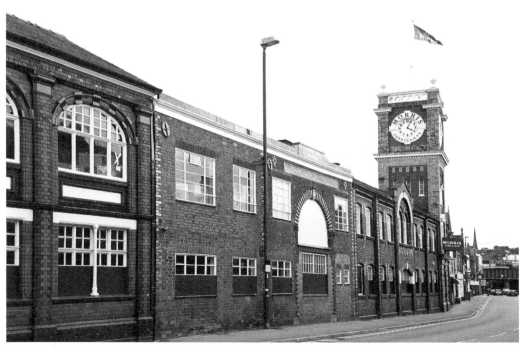

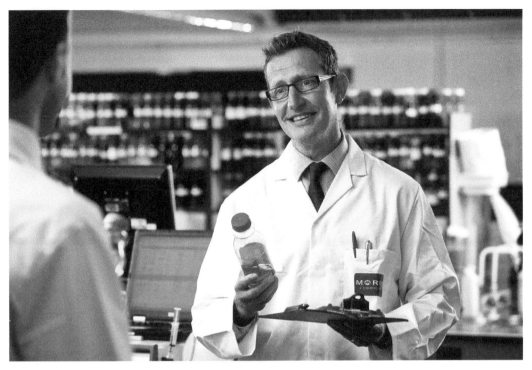

Above: In the research facility seeking high-performance product improvement in Castle Foregate. (Morris Lubricants)

Below: Morris Lubricants specialise in products for heritage vehicles such as this Sentinel steam wagon. (Morris Lubricants)

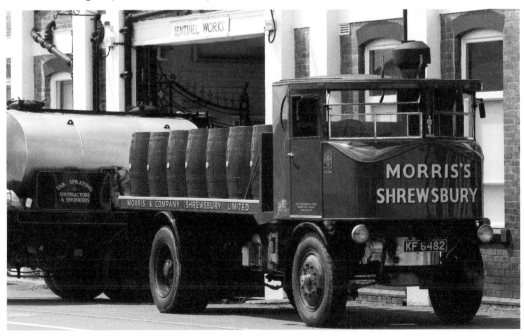

SILHOUETTE CORSETS AND HARTLEY ELECTROMOTIVE

A company moved to the Midlands to escape the bombing in London and by the toss of a coin decided to come to Shrewsbury rather than Coventry. The company eventually provided employment for over 3,000 people, mainly women sewing machinists, and did much to improve working conditions and aid the independence of women throughout Shropshire, as many took home more pay than the men in their lives. Another company, Hartleys, was founded in the town and again took advantage of the post-war boom in the demand for housing and in consumer goods. Although both companies are no longer operational, the products are made elsewhere and the buildings are still in use.

SILHOUETTE

Silhouette started in Cologne in 1887 when Max Lobbenberg and Emil Blumenau teamed up to make corsets and, initially, dressing gowns. Because of the difficulties for Jewish-owned companies in Germany in the 1920s and '30s, the company developed an international business with operations in London, Paris and the USA. The second generation, Otto and Hans Lobbenberg and Hans Blumenau, joined the firm as partners in 1923. Otto from the Paris office had obtained the manufacturing rights for a new and revolutionary garment, 'a radio-active corset', certified by Marie Curie. With 'a stimulating and rejuvenating influence on the cells of the human body, it would aid fatigue, warm the body and help rheumatic pain'. It was called 'Silhouette Radiante' and it was an immediate success.

After a move to London the company had to relocate again because of German bombing. It moved to Shrewsbury in 1941, to the tiny Tankerville Street church hall. Here corsets were refurbished, repaired and returned to their original owners, but the company benefitted from orders from the military and Silhouette made bras and suspender belts for WAFS, ATS and WRENS.

The company moved to larger premises in Coton Hill, but by 1956 they had outgrown these premises – as can be seen from the busy shipping department – so the company moved again, to a purpose-built factory in Harlescott, on the north side of Shrewsbury. Shortly after the move to Harlescott, Annemarie Lobbenberg, as the company's chief designer, was inspired to invent a revolutionary new girdle (an undergarment used to hold up stockings) using new materials of nylon and Lycra. Named the little X, it was an instant and huge success.

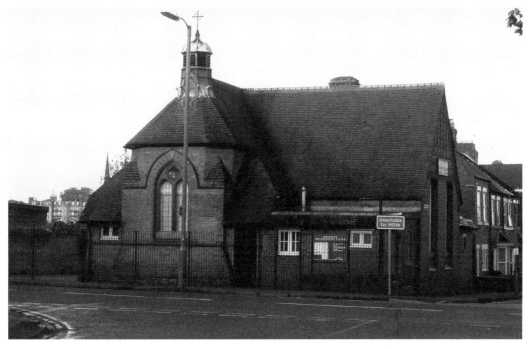

Above: Tankerville Street Church Hall, Silhouette's first location. (Nigel J. Hinton)

Below: Silhouette expansion into Coton Hill Church. (Nigel J. Hinton)

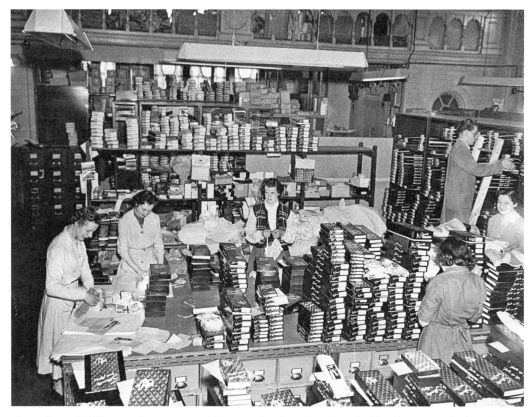

Above: Coton Hill Shipping Department. (Blumenau family archives/now held in Shropshire Archives)

Below: New factory, Harlescott, now BT. (Nigel J. Hinton)

As a result of this success Silhouette grew to be one of the town's largest employers. It opened factories in other locations in and around Shropshire, at Market Drayton, Whitchurch, Telford and Chirk. At its peak over 3,500 people were employed and in 1959 the company was floated on the London Stock Exchange. The social side of the business was important to the owners, who arranged social clubs and events for their employees. Later the threat from a change in fashion to short skirts and tights drove Silhouette to look at the market and increase its range of products, diversifying into swimwear, cruise wear and sportswear.

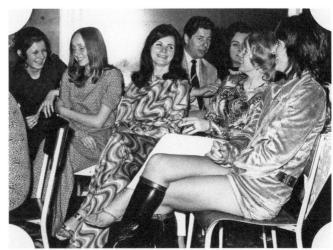

Right: Silhouette social event. (Blumenau family archives/ now held in Shropshire Archives)

Below: Sylvia Brown keep fit class. (Blumenau family archives/now held in Shropshire Archives)

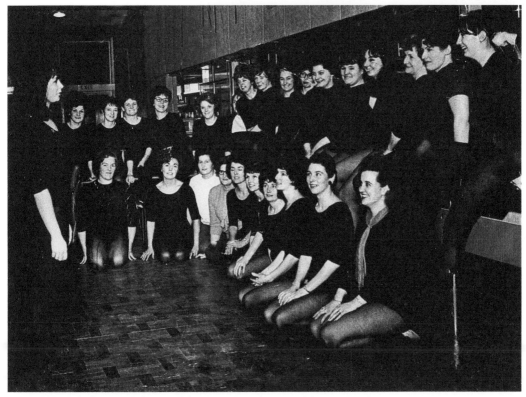

Above: Sewing machinists at Harlescott. (*Shropshire Star*)

Below left: A 'Little X' open girdle made by Aras and Nijole Gasiunas, owners of Silhouette.

Below right: Kerry Mason, Thighs The Limit, with a Silhouette girdle. (Nigel J. Hinton)

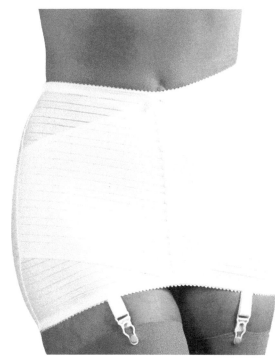

The cornerstone of the Silhouette business, the corset, was obsolete and the factories began closing until the business was taken over by W. L. Pawson & Son Ltd in 1979. But within a couple of years they had collapsed and the remaining Shropshire factories were closed down. The brand name was sold on and Silhouette corsets are now made in Europe and distributed from Manchester by Aras and Nijole Gasiunas, owners of Silhouette. Silhouette-branded products are available from Kerry Mason, at Thighs the Limit, Mardol.

HARTLEY ELECTROMOTIVE

Hartley Electromotive came into being after a series of moves, mergers and relocations within Shrewsbury when Bill Hartley set up Hartley and Co., electrical engineers. He linked up with John Symonds and in 1949 moved to Monkmoor Road, setting up a factory in some aircraft hangars that had been used to repair airplanes during the First World War. They needed the space to fulfil some major orders for wiring kits for 20,000 houses to be made for Airey Homes of Leeds. Eventually over 250,000 kits were supplied for the home and export markets. By 1950, Hartleys had acquired Duratube and Wire Ltd of Feltham, Middlesex, who made all the cable for Octopus, the brand name for the wiring kits, and other related products and a year later acquired Trust Accessories.

In 1954, the company made the national headlines when Hartleys took over Baird Television Ltd, and a new company, Hartley Baird Ltd, was formed. Mr Hartley was appointed managing director. The company made the most of the post-war consumer boom and produced a wide range of electrical and mechanical products including wood-burning stoves, television sets for Radio Rentals, radio sets for the HMV brand and they also designed their own products

Hartley Works. (Nigel J. Hinton)

Former employees with a HMV radio: Nigel Cutting, Barry Gwilt, Ray Leech and the late Ken Lock. (Nigel J. Hinton)

including the Wondergram, the Supergram and the Ambassador Radiogram. The company developed an early tape cassette system called the Tape Riter. It used full-size reels in a metal case that could be lifted off one recorder then placed on another machine and replayed by a typist, who would transcribe the tape.

At its peak the company employed 700–800 people with a wide variety of skills, including metalwork, machining, plating and painting, wiring and electrical assembly, which enabled the company to produce a whole variety of electrical and electronic products for industrial and domestic use, including technical equipment such as oscilloscopes.

The company trained many of its employees in its own training school, either formerly or with on-the-job training, and valued its own apprentices. There was increasing competition and technology was changing. Orders were decreasing and in 1972 a receiver was called in. First to go was the Octopus Wiring division, which was sold to Rists Wires and Cables and moved to Lancaster Road. The remainder of the business was sold to C&N Electrical Industries and they became part of the Cray Electronics Group, who took over and set up a separate company in 1979 – Shrewsbury Electronic Engineers Ltd. The new company continued to make products, including microfiche readers, for Barclays and Directory Enquiries, before computers replaced the readers. The company rebranded as Shrewsbury Technology and continued to develop new products, but when the Cray Group itself got into difficulties, Shrewsbury Technology was closed in 1993. A reunion was organised in 2006 and Mr Hartley's daughter brought along an Ambassador Radiogram.

The large factory has been split up into smaller units and several businesses are currently based in Hartley Works.

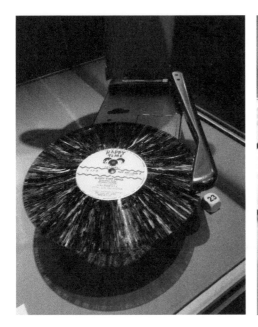

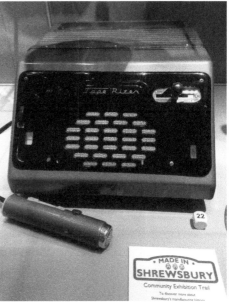

Above left: The amazing portable Wondergram. Is this the smallest record player in the world? (Nigel J. Hinton)

Above right: Tape Riter made by Hartleys. (Nigel J. Hinton)

Below left: Oscilloscope made by Hartleys. (Nigel J. Hinton)

Below right: At a reunion in 2006 when Bill Hartley's daughter brought along an Ambassador Radiogram made by Hartleys. (Nigel J. Hinton)

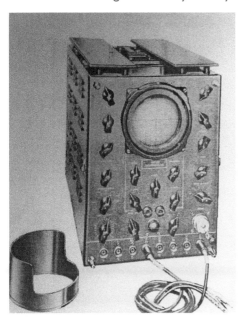

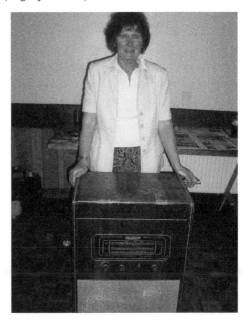

Reunion picture of former workers from Hartleys. (Nigel J. Hinton)

SALOP DESIGN & ENGINEERING AND SALOP LEISURE

This chapter discusses two businesses that started in the 1960s and have expanded successfully in specialist areas of engineering and leisure using the old county name for Shropshire.

SALOP DESIGN & ENGINEERING LTD

Salop Design & Engineering Ltd has its roots in a business started in 1960 by Mr Richard (Dick) Homden. He started designing press tools for the automotive manufacturing industry from an office in the High Street. Mr Homden was then asked to install a press to try out and

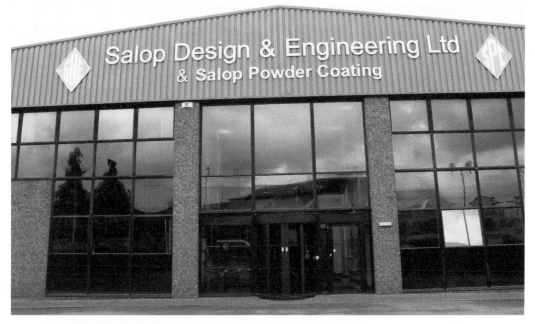

Salop Design & Engineering Ltd, Brixton Way. (Nigel J. Hinton)

prove the tools before they went to the manufacturers. He purchased more presses when he was asked to supply more components from the tools he designed and manufactured, and in 1967 the Salop Design & Engineering Ltd was formed. The company manufactured at the Condover Industrial Estate and later moved to Lancaster Road, in Harlescott, to make press tools for Stadco. Since then SD&E has been manufacturing metal pressings and assemblies as a Tier 2 supplier. Their parts end up in OEM's (original equipment manufacturers) such as Jaguar Land Rover, Nissan and BMW.

In 1996, the new factory was built and further extended in 2004 to 8,000 square metres. This new building allows a very smooth process to flow as all the business activities are carried out in one location and the consolidation has given greater control over the manufacturing processes.

In 2012, the company invested in the first of two powder-coating lines, and since then has continued the investment in the new factory. The directors have invested over £2.5 million on the site. The company continues to make and service its own tools in the specialist tool shop. The company has been awarded 'Investors in People' status and in 2015 the company invested in a bespoke training centre. Now working with In-Comm, a training provider, the In-Comm Training Academy is training engineering apprentices for Shropshire and many trainees will join the team of 100 people who work at the SD&E.

A sister company, Salop Haulage Ltd, who operate from their depot behind SD&E, take care of all customer haulage requirements and have grown with SDE to a fleet of eighteen vehicles. Salop Haulage's MD, Mr Brian Davies, started with SD&E in January 1967, making deliveries in a Morris 1000 van. He has been with this family firm man and boy and he will remember how the factory used to be before the investment.

Verson Wilkins press. (Nigel J. Hinton)

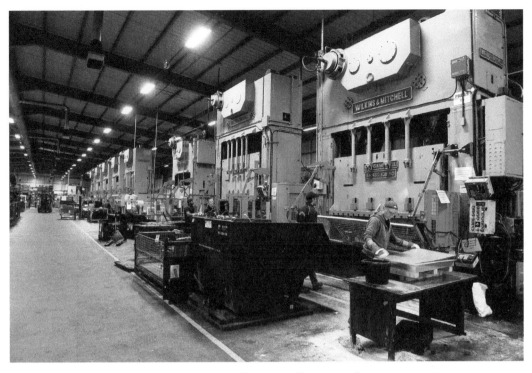

Above: Verson Wilkins press line. (Salop Design & Engineering)

Below: The start of the powder-coating process line. (Nigel J. Hinton)

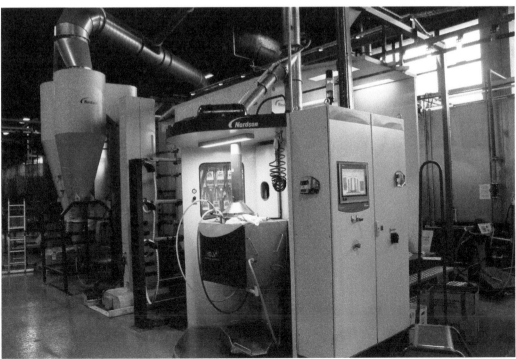

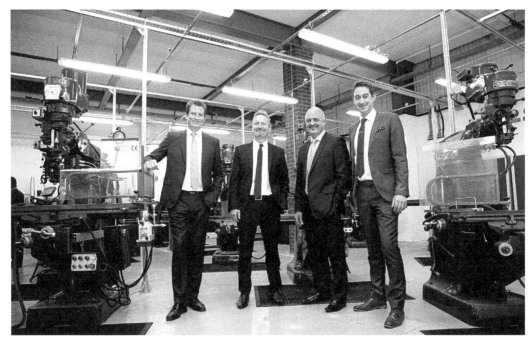

Above: From left: Richard Homden, Managing Director, Salop Design; Christopher Greenough, Commercial Director, Salop Design; Lee Pearson, Engineering Director, Salop Design; Gareth Jones, Managing Director, InComm Training. (Salop Design & Engineering)

Below: Tool shop. (Nigel J. Hinton)

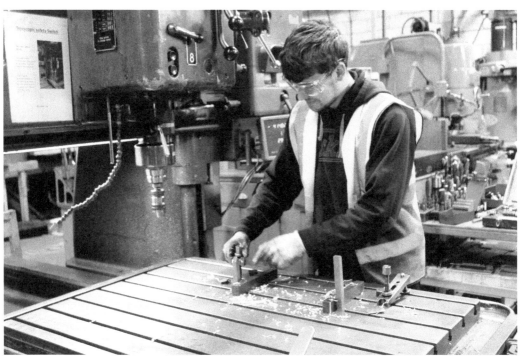

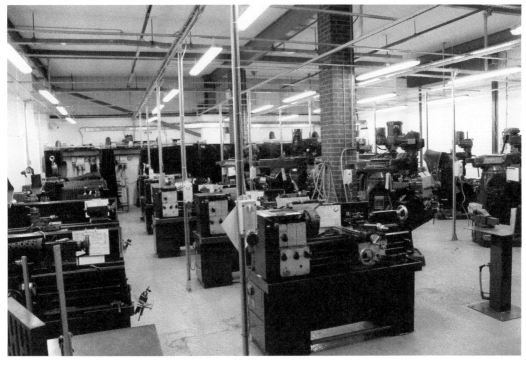

Above: Apprentice school. (Nigel J. Hinton)

Below: How it used to be before the investment. (Salop Design & Engineering)

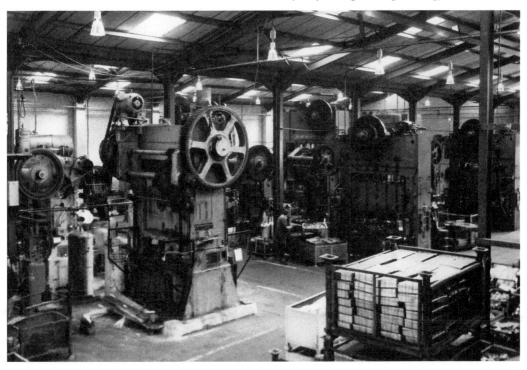

SALOP LEISURE

Salop Leisure is another successful local company that started in the 1960s. It was established by Mr and Mrs G. Betts, who had the vision to open a new caravan business at Downes's Garage in Meole Brace. Mr Betts had previously worked at Pascals, in Oakengates, selling and servicing caravans, and he thought there was an opportunity to do this on the main route to Wales in Shrewsbury, so the Salop Caravan Centre was born. The focus was on customer service and the small team gradually built up, with Mr Tony Bywater joining the sales team in 1966. The business continued to expand in spite of the fuel shortages of the 1970s and the recessions of the 1980s and '90s. They exhibited in Earls Court and always used fresh flowers supplied by Percy Thrower, whose garden centre flourished a few hundred yards away on Oteley Road.

In 2006, a management buyout of the company by the senior employees saw some new developments. The new company relocated to Emstrey and built a state-of-the-art caravan showroom and service centre on the A5, at the main south-east entrance to Shrewsbury. This now incorporates Love Plants, which is not a garden centre but is a dedicated plant centre that sources plants, trees and shrubs locally. A new café-restaurant, Love Coffee, is a comfortable meeting place that also operates from the site, which is collectively known as Salop Leisure.

Recently there has been a revolution in the world of camping and twelve new glamping units have been introduced with a new caravan and camping resort has been established on 22 acres of Shropshire countryside adjacent to Salop Leisure.

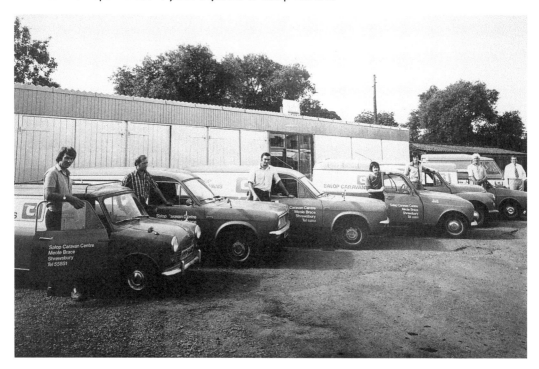

Service vehicles with Mr Betts on the right. (*Shropshire Star*)

Above: Percy Thrower with Tony Bywater. (Salop Leisure)

Below: Salop Leisure main entrance. (Nigel J. Hinton)

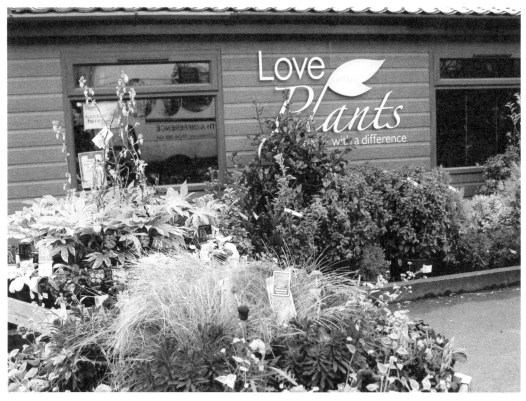

Above: Love Plants. (Nigel J. Hinton)

Below: Love Coffee. (Salop Leisure)

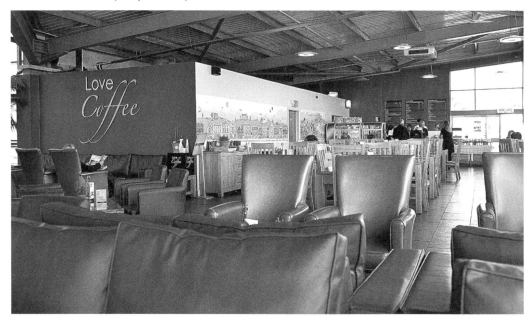

Above: Glamping at Christmas. (Salop Leisure)

Below: Love to Stay. (Salop Leisure)

Higher levels of customer expectation were matched by high levels of build quality and finish and customers have an increased appetite for luxury fittings, so today's offerings by the caravan manufacturers have to match this demand. As a result, prices have increased accordingly.

Salop Leisure has gained a reputation for good customer service and the company encourages its staff to maintain their skills by providing continuous training. It particularly supports young people by offering work experience to those at school and believes in on-the-job training and apprenticeships for other employees. The company employs over 200 people on the Emstrey site.

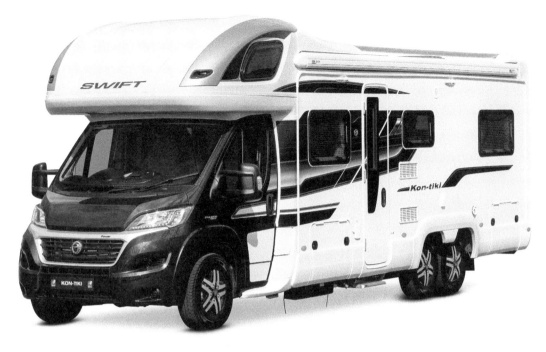

Above: A top-of-the-range motorhome: a Kon Tiki 649. (Salop Leisure)

Below: Salop Leisure service team, 2017. (Salop Leisure)

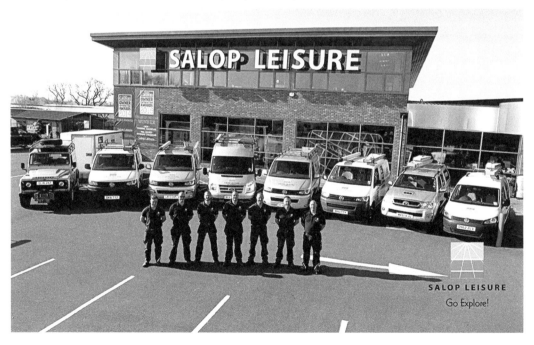

CONSTRUCTION AND PERSONAL HEALTHCARE

I n this chapter we will look at the growth of personal healthcare as health is the largest employment sector in Shropshire, with 14.7 per cent of the total jobs in the county, the majority of them in Shrewsbury, in public health. Following the closure of local authority care homes, the private sector has grown to take over the care of elderly people.

MORRIS & COMPANY

Morris & Company is the largest of the private sector employers in healthcare with its Morris Care range of nursing homes, and it also has a substantial property holding and construction footprint within the town. It traces its foundations back to 1869, when James Kent Morris opened a grocery store in Frankwell, as seen in chapter 'Perseverance Ironworks and Morris Lubricants'. Today, the fifth generation are running a diverse and successful company in care, property and site machinery from its stylish head office on the English side of the Welsh

FOUR BROTHERS

Herbert Morris James Kent Morris Frederick Langley Morris Henry Morris

Four brothers. (Morris Lubricants)

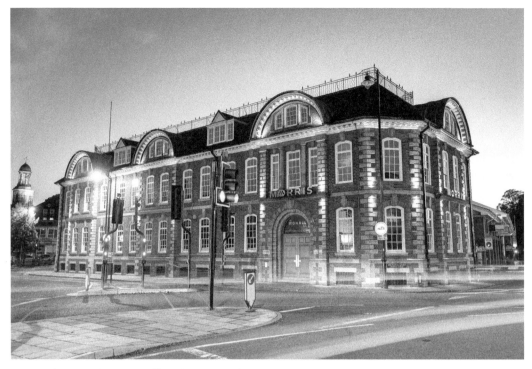

Above: Morris & Co. head office. (Morris & Co. collection)

Below: Dave Mellor Cycles, former HQ of Morris & Co. (Nigel J. Hinton)

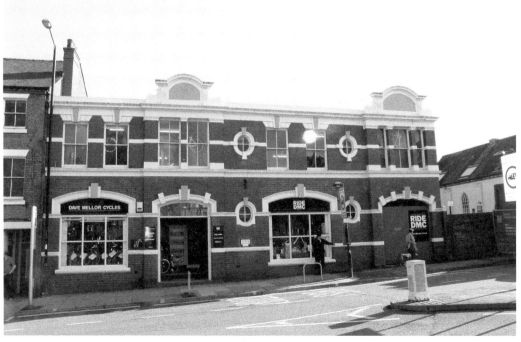

Bridge, which it built in 1922. Its former head office in Frankwell is now occupied by Dave Mellor Cycles.

In 1988, the company designed and constructed a purpose-built nursing home at Radbrook Green, and launched Morris Care. This was the brainchild of Bill Morris, then chairman of the company who wanted somewhere of the highest quality to care for his mother. Today Morris Care comprises six nursing homes offering specialist nursing care, employing 572 nurses, carers and support staff across its Isle Court and Radbrook nursing homes in Shrewsbury and four other homes across Shropshire and Cheshire.

Morris Property has over 100 years' heritage of building, restoring and leasing property and today owns and manages a substantial 225-strong property holding. Its construction arm also builds residential and commercial projects on behalf of clients, ranging from student accommodation for University Centre Shrewsbury to Drapers Place for the Shrewsbury Drapers Holy Cross Ltd.

Isle Court nursing home in Shrewsbury. (Morris & Co. collection)

Above: Timothy Morris, director, with the team. (Morris & Co. collection)

Left: Nursing staff with resident at Isle Court. (Morris & Co. collection)

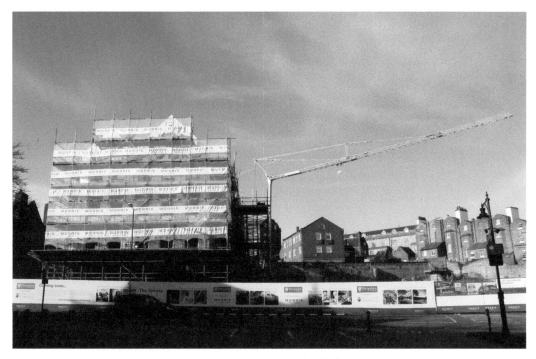

Above: Construction of new halls of residence for USC. (Nigel J. Hinton)

Below: Keys handover in Drapers Place from Morris Property to Richard Auger on behalf of the Shrewsbury Drapers Co. (Shrewsbury Drapers Co.)

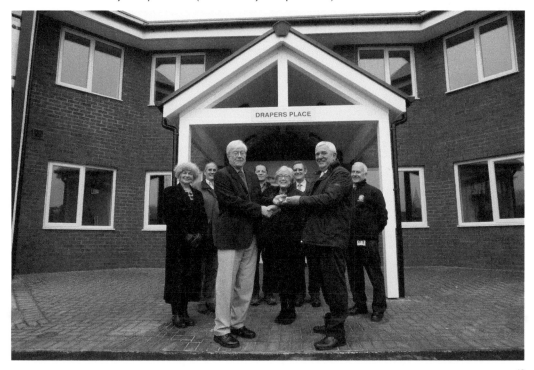

Swan Hill House with tax-saving windows. (Nigel J. Hinton)

SWAN HILL HOUSE

Swan Hill House offers a contrast to purpose-built care homes as it is set in the heart of Shrewsbury, in an elegant Georgian town house convenient for all town amenities. Once owned by William Hazledine, the house has been converted in keeping with a Georgian Grade II-listed building; each of the rooms has its own unique character and style. The Georgian elegance extends to the main yellow dining room and the large drawing room, and there is also a smaller cottage dining room and a sitting room often used by residents when entertaining their guests, who can also access the beautiful gardens, which are an integral part of Swan Hill House.

Swan Hill House was started by the late Peter and Carol Daker. Now their son Charles, supported by Carol, has taken responsibility for the home and the residents, assisted by registered manager Melanie York and senior duty manager Linda McAvoy. There are up to thirty full-time and part-time people employed in the home.

THE UPLANDS

The Uplands was founded in Dorrington by Tricia and Tony West and prides itself on quality nursing care in a homely environment. The Uplands relocated to Oxon, near the Severn Hospice, in 2008 and is now under the management of their daughter Mrs Many Thorne MBE and husband Mark. The Uplands was purpose-built to include light and airy day rooms with access to the landscaped courtyard with wheelchair-accessible gardens and an outdoor terrace with views of the Shropshire Hills.

Volunteers are encouraged to visit the Uplands through national volunteering schemes, as part of school's projects, or as part of the outreach from our local church and faith communities. There is also a Day Resource Centre. Around 150 people are employed in the Uplands, where continuous training is the watchword and modern apprentices study the National Vocational Qualification.

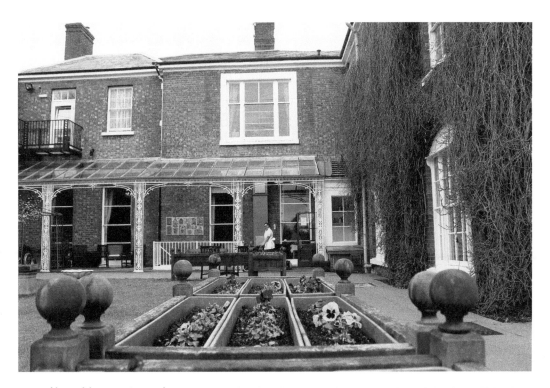

Above: Manager in garden
at rear of Swan Hill House.
(Nigel J. Hinton)

Right: Tony and Tricia West.
(The Uplands)

Above: Mandy and Mark Thorn.
(The Uplands)

Left: Day Resource Centre.
(The Uplands)

RADFIELD HOME CARE

Radfield Home Care offers support and care for people living in their own homes. Starting in August 2007, Alex Green and Dr Hannah Mackechnie have built a team of thirty-four people and are based at No. 7 Frankwell, Shrewsbury.

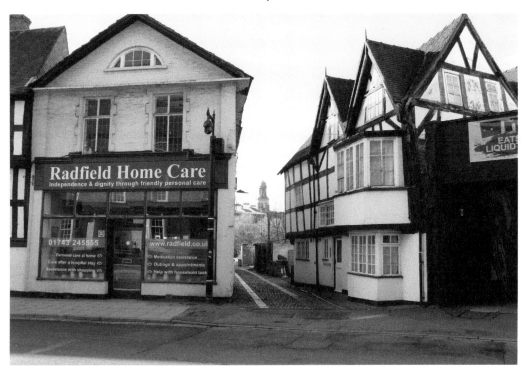

Above: Radfield Home Care at No. 7 Frankwell. (Nigel J. Hinton)

Right: Dr Hannah Mackechnie and Alex Green. (Radfield Home Care)

THE RISE OF THE PROFESSIONALS

In the last 250 years an increasing amount of complex legislation has been added to the statute book and this has further dramatically accelerated in the last fifty years. This chapter examines some of the roles played by the professional advisers who have set up business in Shrewsbury. The Law Society represents, promotes and supports solicitors in England and Wales. The Royal Institute of Chartered Surveyors was founded in 1868 and the Institute of Chartered Accountants in England and Wales was founded in and granted its royal charter in 1880. These bodies insist on high personal and professional standards for their members and have rigorous training schemes and a requirement for continuous professional development to be undertaken.

WACE MORGAN SOLICITORS

Wace Morgan Solicitors can trace its foundations to 1752, when Robert Pemberton set up practice as a lawyer. He was joined by his son and William Coupland in 1787. Thomas Salt was articled (signed a training contract) to William Copeland and he joined the partnership in 1815. Salt acted for Dr Robert Darwin, who built the Mount House (birthplace of his son Charles) and as he lent money on security of property, Salt was kept busy.

By 1837 Richard and Henry Wace started their practice in College Hill in Shrewsbury and a couple of years later Thomas Salt relocated to No. 10 Belmont. George Morgan moved his practice, founded in 1893, to No. 2 Belmont in 1920. In 1971, G. R. Wace and C. E. Wace merged with G. H. Morgan and Sons and the practice traded as Wace Morgan from No. 2 Belmont until 1978 when Salt & Sons joined them and they traded as Wace Morgan & Salt from Nos 1–2 Belmont. The company opened a law shop in the High Street as extra office space was needed; this was officially opened by David Lock QC MP.

While the traditional work of lawyers in a rural community is private client work relating to property, probate and wills, there is more advice required now for elderly client care funding, employment, personal injury, family and child care, family mediation and arbitration, social housing and development, and forces law. Land and property sales and wills and all companies' house matters have to be filed online and there has been a growth in practice compliance work. All work is now consolidated in offices in St Mary's Street, where the company employs ninety-two people.

Above: The Mount House, home of Robert Darwin and birthplace of his son Charles Darwin in 1809. (Nigel J. Hinton)

Right: Richard Wace painted by William Roos in 1844. (Wace Morgan collection)

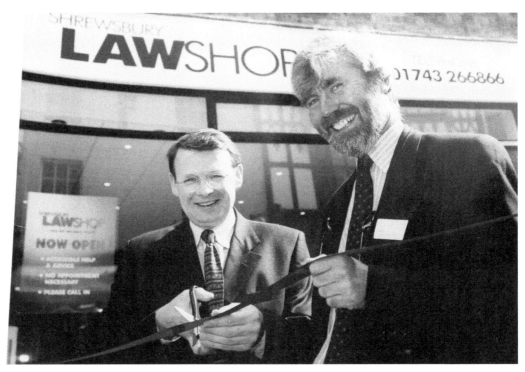

Above: Law Shop in High Street opened by David Lock QC, MP for Wyre Forest, and Trevor Wheatley, partner in Wace Morgan. (Wace Morgan collection)

Below: Wace Morgan team. (Wace Morgan collection)

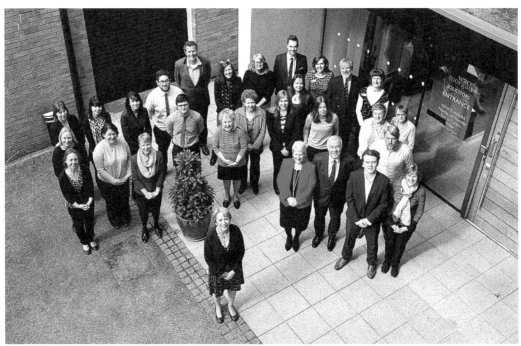

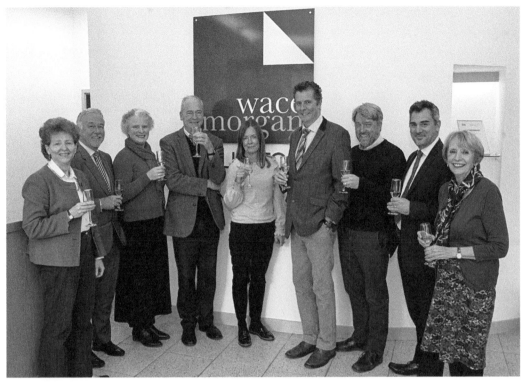

Above: Partners of Wace Morgan. (Wace Morgan collection)

Below: New offices in St Mary's Street. (Wace Morgan collection)

WHITTINGHAM RIDDELL LLP, CHARTERED ACCOUNTANTS

Whittingham Riddell LLP, chartered accountants, has a long history and can trace its origins as far back as 1899. The firm came into being with the merger of two accountancy practices in 1967: Wheeler, Whittingham and Kent and Asbury Riddell. The firm took the name of the senior partners from each of those firms and has retained their names with Doug Whittingham and James Renwick Riddell, who had followed his father, of the same name, into the practice in 1950. In 2004, after thirty years at No. 15 Belmont, it was decided to relocate to purpose-built offices on the Shrewsbury Business Park. The firm affectionately retained the connection to the past in naming the new property Belmont House, which currently houses its 115 Shrewsbury-based staff.

Above left: Doug Whittingham, chartered accountant. (Whittingham family collection)

Above right: James Renwick Riddell junior, chartered accountant. (Jane Shaw Riddell family collection)

Left: James Renwick Riddell senior, chartered accountant. (Jane Shaw Riddell family collection)

Above: New Belmont House. (Nigel J. Hinton)

Below: Teamwork at Belmont House. (Nigel J. Hinton)

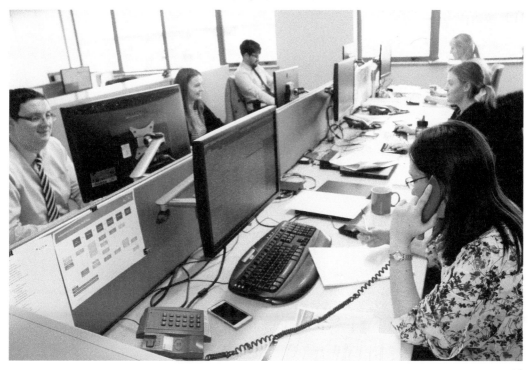

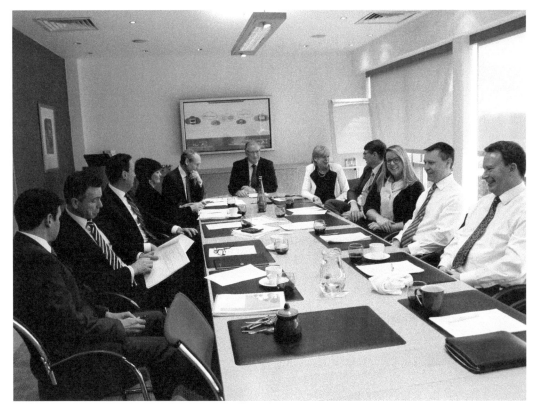

Board of Whittingham Riddell. (Nigel J. Hinton)

HALLS

Halls, originally known as Hall Wateridge & Owen, was founded in 1845. The present company continues the traditional and professional service its reputation is built on. The range of services is appropriate to a rural county and includes sales and auctions of residential, commercial and agricultural property, fine arts, antiques, and weekly sales of livestock are held. The newly built headquarters, fine art salerooms and livestock auctions in Battlefield, Shrewsbury, were opened by Tim Wonnacott on 15 March 2013.

ROGER PARRY

Roger Parry is an auctioneer and estate agent who launched his business in 1981. The Shrewsbury office is now based on the Welsh Bridge and the business employs thirty-four people. Roger was president of the Shropshire Chamber of Agriculture (SCoA) in 2017.

SCoA was founded in 1865 and represents 330 Shropshire members with an interest in agriculture. The Shropshire Chamber of Agriculture is the only survivor of all the other county chambers that were formed in the nineteenth century.

Above: Halls livestock auctions. (Nigel J. Hinton)

Below: Roger Parry and his team. (Roger Parry)

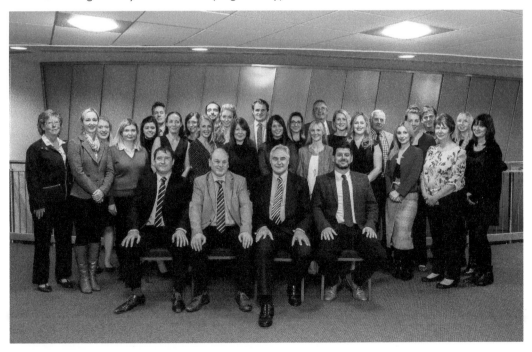

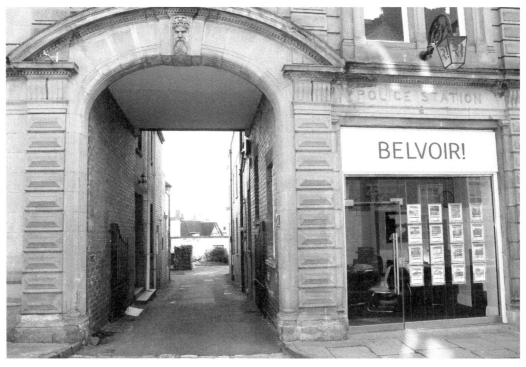

Above: Belvoir in the Old Police Station, Swan Hill. (Nigel J. Hinton)

Below: Holland Broadbridge are celebrating twenty-five years in Agricultural House, where the local branch of the National Farmers' Union started in 1908. Other estate agents include Halls, Cooper Green Pooks and Miller Evans. (Nigel J. Hinton)

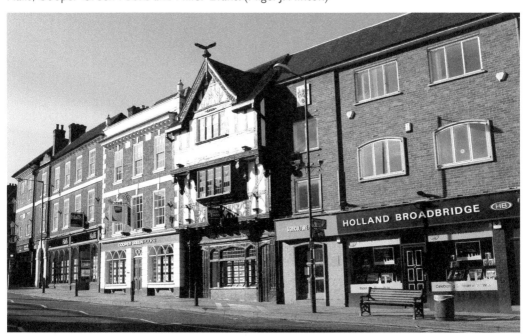

BELVOIR

Belvoir is a national franchise that started as a specialist lettings agency and in the last three years it has migrated into a full estate agency including sales. Paul Wallace-Tarry took over the franchise in 2003 and employs eight people in the offices based in Swan Hill. Richard Wallace-Tarry joined the business in 2016 and is now lettings director.

HOLLAND BROADBRIDGE

Holland Broadbridge was started by Gary Holland and Sandra Broadbridge, who this year are celebrating twenty-five years in business as estate agents, selling and letting houses from their base at Agriculture House in Barker Street. There are fifteen employees including an apprentice and a former apprentice who has now joined the team. Barker Street has a number of estate agents in addition to Holland Broadbridge; there is Miller Evans, Halls and Cooper Green Pooks.

LEISURE AND THE CAFÉ SOCIETY

While the number of public houses has reduced in the suburbs, many flattened to make way for housing developments, within the town centre there has been an explosion in the number of food and drink establishments. A recent trend is the number of shops offering only puddings or sweets, such as Treat on Abbey Foregate. Some have started up in buildings with a history of wining and dining and others have set up in former retail shops that are no longer viable due to the competition from online shopping. Even the town centre churches have seen an opportunity to advance their fundraising with new and improved tea and coffee shops.

THE GOLDEN CROSS

The Golden Cross has a long history dating back to 1428. It is adjacent to old St Chad's Church and was once used as the sacristy. It was connected by a footbridge over Candle lane, now Princess Street. It was a place where gentlemen and cavaliers met and were entertained in the seventeenth century and it is believed to be the first licensed house in Shrewsbury.

Gareth and Theresa Reece took over in 2002. Theirs was one of the first of many new restaurants that set up in the town in recent years. Currently there are twenty people who work in a variety of roles in the hotel and restaurant.

THE PRINCE RUPERT HOTEL

The Prince Rupert Hotel was acquired in 1998 by Michael Matthews. It is a combination of two adjacent hotels, one facing Church Street and the other Butcher Row. It has timber framing inside and below there is stonework in the cellars dating back to the thirteenth century. Camelia's is a traditional tearoom with a modern twist.

Other hotels, restaurants and coffee shops in the centre of Shrewsbury are a mixture of independent owner-managed businesses and national brand franchises seen in most towns and cities in the UK. Many are located in historic buildings and others have set up in the town centre churches.

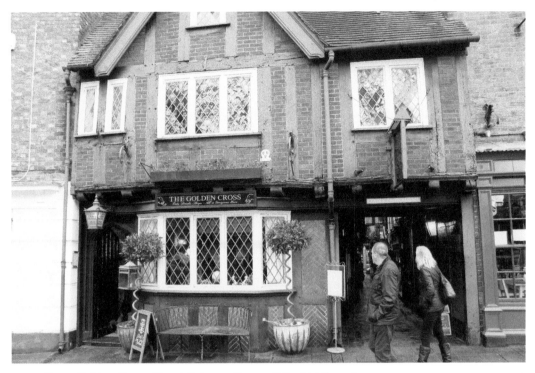

Above: Golden Cross Hotel, Princess Street. (Nigel J. Hinton)

Below: Prince Rupert Hotel, Butcher Row. (Nigel J. Hinton)

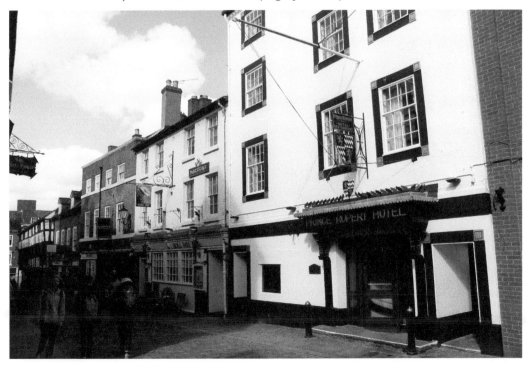

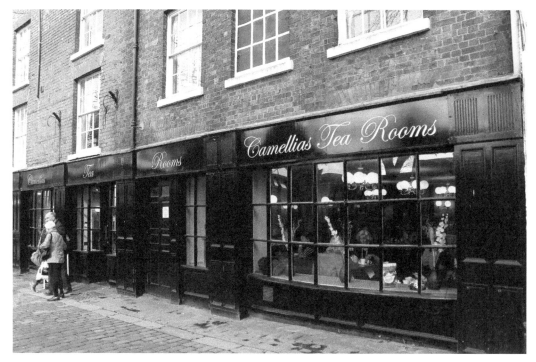

Camellias, Butcher Row. (Nigel J. Hinton)

RENAISSANCE, GINGER & CO. AND CARLUCCIO'S

Renaissance, Ginger & Co. and Carluccio's are all found in Princess Street and in the ancient cruck houses on Abbey Foregate there is an entertainment hotspot with a choice of fine dining and late-night clubbing.

PALMERS

In the former Baptist church in Claremont Street, Palmers is a coffee shop with rooms available for hire.

DRAPERS HALL

In the restored timber frame of Drapers Hall there is fine wining and dining with a bijou hotel with a high standard of accommodation, food, wine and service.

TANNERS WINES

Tanners Wines celebrated its one 175th anniversary last year and has become an exceptionally popular and award-winning wine merchants. Its website lists awards for at least the last ten

Above: Restaurants and café in Princess Street: Renaissance, Ginger & Co. and Carluccio's. (Nigel J. Hinton)

Below: Entertainment hotspot Abbey Foregate. (Nigel J. Hinton)

 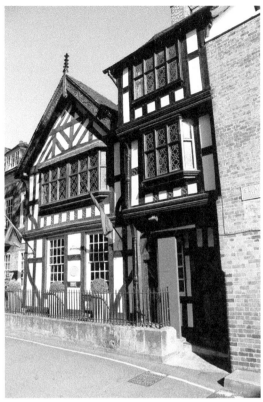

Above left: Palmers in Claremont Street. (Nigel J. Hinton)

Above right: Drapers Hall, St Mary's Place. (Nigel J. Hinton)

years. It is based at the bottom of the Cop (Wyle Cop) where its serves trade and retail customers. An area has been left in the cellar as a time capsule where visitors can step back and imagine times past.

THE ORCHARD CAFÉ AND 1403

The Orchard Café is attached to the Cathedral on Town Walls and has become a popular meeting place for food and beverages.

1403 has taken over the vestry in St Mary's Church and provides a relaxing and quiet space in this spectacular setting.

Hairdressing is included in the BID statistics along with hotels, restaurants, tea and coffee shops and an example of a successful local business is Michele Evans, who started Fusion Hair and Beauty ten years ago as an independent owner-managed business. Here apprentices are trained in association with Shrewsbury College. As with other businesses the range of products and services has increased to meet customer expectations.

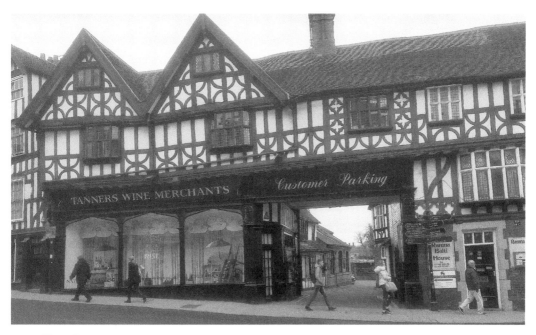

Above: Tanners Wines, Wyle Cop. (Nigel J. Hinton)

Below: Orchard Café on Town Walls. (Nigel J. Hinton)

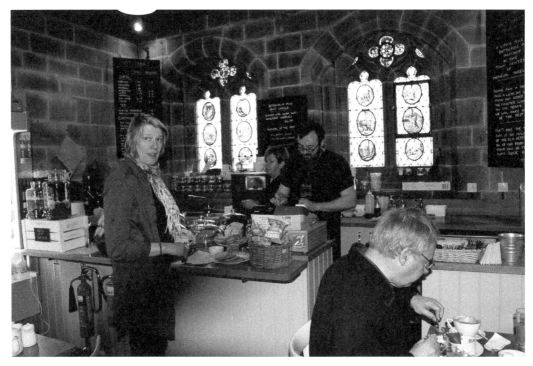

Above: 1403 in St Mary's Church. (Nigel J. Hinton)

Below: The Fusion team. From left: Toni, Charlotte, Mae, Laura and Michele. (Nigel J. Hinton)

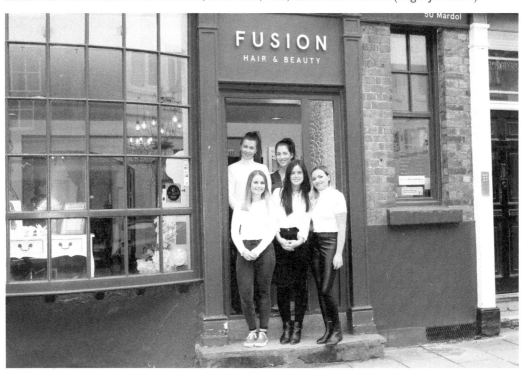

SHREWSBURY MARKET HALL

The present Shrewsbury Market Hall opened in 1965 and replaced the Victorian General Market that opened in 1869. It created much controversy when the Victorian General Market was declared not fit for purpose in the 1960s, as it was insanitary and lacking in amenities and it did not have services appropriate to a modern market hall. Shrewsbury Market Hall's new design was compared to a cruise ship' or 'battleship', and was hailed 'the most modern building in Shropshire' when it officially opened in 1965. Although the Pevsner guide said it was 'a good example of modern architecture, hence its clean lines and simple forms', the majority of the public thought it ugly and unsightly. Today it is an important commercial building at the heart of the town, with a landmark 240-foot clock tower housing its thriving indoor market and the town's first halls of residence of the University Centre Shrewsbury.

In 2015, Shrewsbury Market Hall celebrated the fiftieth anniversary of the opening of the 1960s building in January 2018 it was voted Britain's Favourite Market by the public ballot organised by the National Association of British Market Authorities.

Permanent shops surround the traditional stalls including the traditional provisions merchants, cheese mongers and butchers A. J. Embrey, John Bliss and William Dodd. Other traditional market businesses have diversified and now include a dining experience.

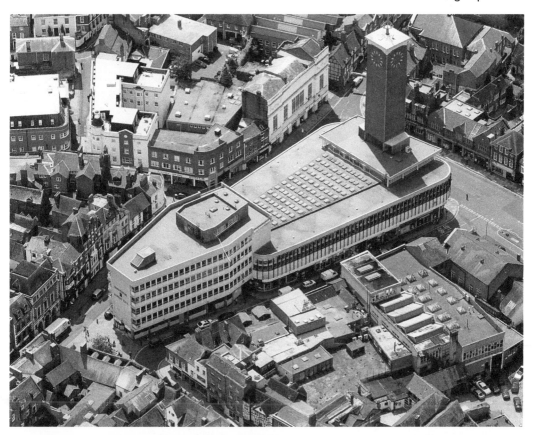

Shrewsbury Market Hall. (Shrewsbury Market Hall)

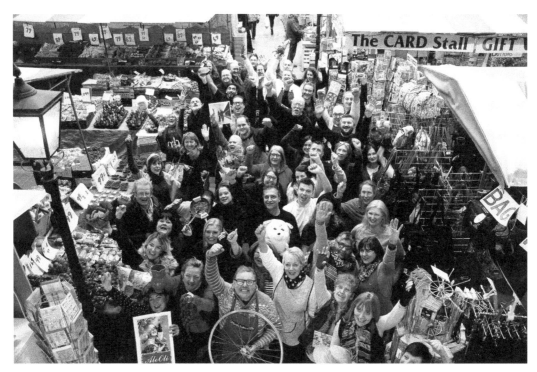

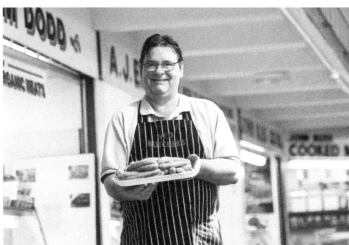

Above: Winners of Britain's Favourite Market 2018. (Shrewsbury Market Hall)

Left: Mr Will Dodd. (Shrewsbury Market Hall)

Barkworths Seafoods, the fishmonger, has expanded to include a Continental-style seafood bar, Saint Pierre Seafood Bar. Other new food businesses include Moli Tea House, which serves Beijing dumplings and Chinese tea, and the Birds Nest Café, which Serves locally sourced produce and organic options. With street food and international cuisine on offer the market has become a desired destination and is open on selected evenings for dining. The traditional suppliers of fresh flowers, fruit and vegetables and farm produce are available along with new businesses offering, a gin bar, books, fashion and designer clothing, vintage and collector's stalls with vinyl records, sheet music, instruments, Hornby train sets and a cycle shop. The market has seventy stalls and over 100 employers/employees.

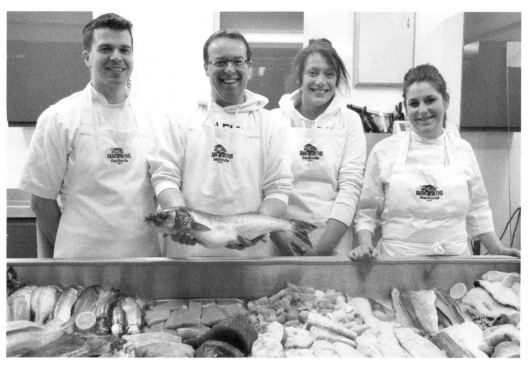

Above: The team from Barkworths Seafood. (Shrewsbury Market Hall)

Below: Saint Pierre Seafood Bar. (Shrewsbury Market Hall)

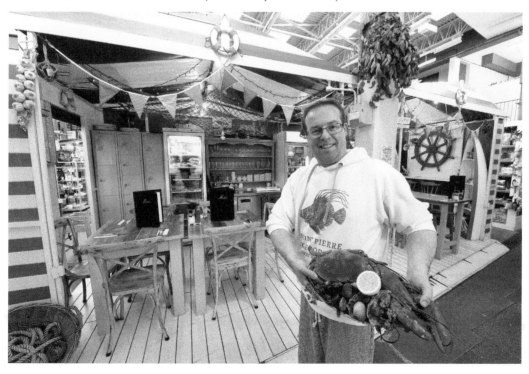

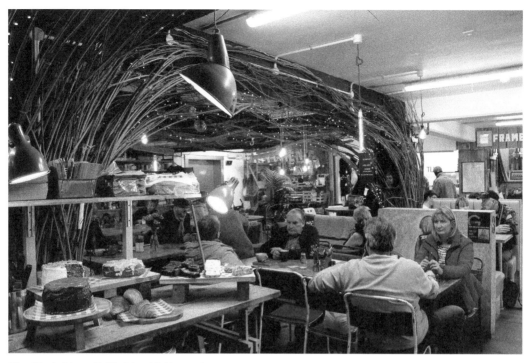

The Birds Nest Café. (Nigel J. Hinton)

Above: The team from the House of Yum. (Shrewsbury Market Hall)

Left: Flowers from Lin. (Shrewsbury Market Hall)

CONCLUSION

SHREWSBURY WAS BUILT ON WOOL

Shrewsbury has survived for over a thousand years by adapting to changes in market demands and there is no doubt there will be further changes in the future. But to close this exploration of a vibrant English market town built on wool we finish with a local sheep story that shows there is still an important market for quality sheep in Shrewsbury. Last year Abbie Moseley, from Knockin, north-west of Shrewsbury, was delighted when her prize-winning ram 'Knockin Shockin' was sold for a record 25,000 guineas, the highest price ever paid for a pedigree Charollais sheep. The ram was bought by another local breeder, Robert Gregory, who farms at Harmer Hill, Shrewsbury.

ABOUT THE AUTHOR

Nigel J. Hinton MA, FCA, is a retired chartered accountant and local historian with a special interest in business and trade. He has lived and worked in Shropshire for almost five decades and is married to Bridget. They have three daughters and five grandchildren. Before retirement he worked as an accountant in manufacturing at GKN Sankey, Serck Audco Valves, Shrewsbury Technology and Intercraft Industries of Chicago, and then for twenty-five years as a director in accounting practice Andrews Orme and Hinton Ltd.

His recent books include *Historical Hostelries* (2005) with David Trumper, *Silhouette* (2011), *Baa Baa Blodwyn* (2011), and *The Shrewsbury Drapers Company 1462-2017* (2017). In his spare time he plays golf and the saxophone (not usually at the same time) and he is a trustee/director of the Shrewsbury Drapers Hall Preservation Trust and the Victoria County History (Shropshire) Ltd and iCanetwork, a cloud accounting company.